THE ART OF
CÉZANNE

KU-082-185

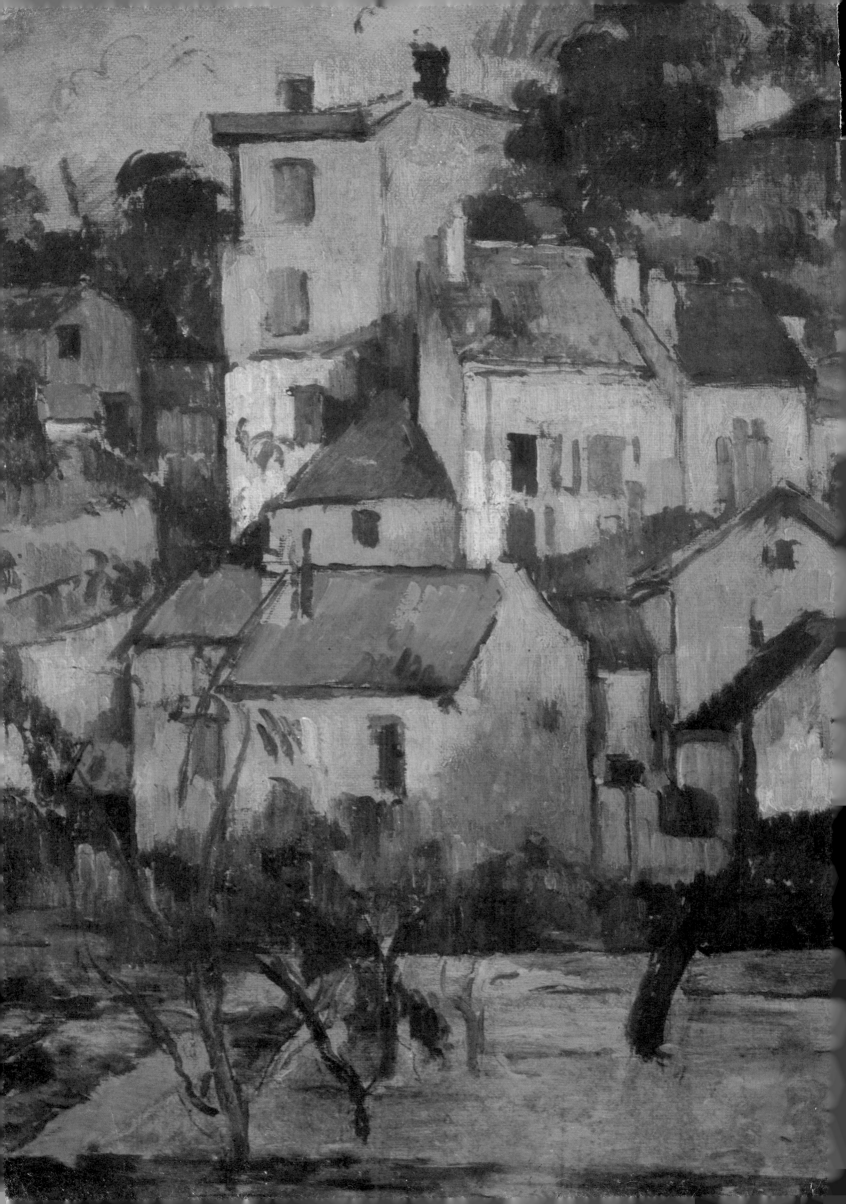

THE ART OF
CÉZANNE
Nathaniel Harris

AMERSHAM COLLEGE OF FURTHER EDUCATION
ART & DESIGN, STANLEY HILL, AMERSHAM
BUCKS. LIBRARY

Optimum Books

M/CEZ
HAR

"/83

AMERSHAM COLLEGE
LIBRARY

7786	L
M/CEZ/HAR	

This edition published by Optimum Books 1982
Reprinted 1983

Prepared by
The Hamlyn Publishing Group Limited
London · New York · Sydney · Toronto
Astronaut House, Feltham, Middlesex, England

Copyright © The Hamlyn Publishing Group Limited 1982

ISBN 0 600 37772 5

All rights reserved. No part of this publication
may be reproduced, stored in a retrieval system,
or transmitted, in any form or by any means,
electronic, mechanical, photocopying, recording
or otherwise, without the permission of The Hamlyn
Publishing Group Limited.

Printed in Italy

Contents

Cézanne:
An Introduction

Madame Cézanne in the Garden. 1872–82. Cézanne met Hortense Fiquet, a seamstress, in 1869. She bore him a son in 1872, but they were not legally married until 1886. Musée du Louvre, Paris.

Far right: *Self-portrait. c.* 1880. One of many self-portraits by Cézanne; early baldness helped to make him look older than his forty years. National Gallery, London.

The 19th century was one of the great ages of French art. In painting, masters such as Delacroix, Courbet, Manet, Degas, Pissarro, Monet, Renoir, Seurat and Gauguin are familiar names – and are, nevertheless, only the best known among a host of gifted individuals, each of whom made a distinctive contribution. Yet many people would argue that, even in this company, Paul Cézanne was the supreme artist, uniting colouristic genius with a sense of structure and design in a way that none of his contemporaries could match. In a revolutionary age he was the arch-subversive. The conventional 'academic' art of the 19th century, insipidly sentimental or escapist, was challenged from several quarters, and the significant history of the period is one of successive liberations – of colour, texture, form and subject-matter. But from our 20th-century point of view, it was Cézanne who took the decisive step. In his practice, and (rather less lucidly) in his remarks on painting, he gave expression to the modern conviction that a work of art is not essentially a copy of reality but is itself an independent reality, a created object with its own inner logic; its relationship with the 'outside' world is oblique, perhaps even (as in abstract art) non-existent. The autonomy of art is a notion central to the modern movements from Cubism to Abstract Expressionism and Pop Art, which are unthinkable without it. As the artist who pioneered this radical break with the past, Cézanne was, according to one of the 20th-century masters, Henri Matisse, 'the father of us all'.

The differences in character that can exist between a man and his art have often been remarked upon; but in Cézanne's case the differences were extraordinary. The great revolutionist was not a swashbuckling Parisian but a morose and solitary provincial, subject to tremendous and conflicting inner pressures. This creator of a calm, ordered and durable artistic world was himself unstable and insecure – fearful of his father's displeasure even while he noisily asserted his independence, alternating between fits of arrogance and dejection, confronting the world with an assumed, self-protective boorishness, and setting himself to outrage artistic juries and public opinion in order to cover up his longing for official recognition. His personal relationships were rarely close in adult life, perhaps as some kind of reaction against a boyhood in which family life had been emotionally intense and friendships ardent; even marriage and fatherhood made little difference to Cézanne's habit of shutting himself away from others for long periods. Socially he was almost impossible, being given to fits of irrational suspicion and pure nervous alarm that might cause him to hurl insults at the company or simply to bolt away from it. Knowing his own weakness, apprehensive that others might ridicule his work or steal his ideas, he narrowed down his circle of friends and laboured on his canvases in something approaching isolation during the last thirty years of his life, until the admiration of a new generation came to provide a limited consolation in his old age.

Cézanne's personal peculiarities help to explain the slowness of his development as painter – a fact that is all the more striking in view of the distance he was ultimately to travel. By the 1860s, older men such as Manet and Degas were exploring the pictorial possibilities of contemporary life, while Cézanne's most gifted close-contemporaries, Monet and Renoir, were painting rapid, brilliant 'impressions' of open-air scenes. In these activities, which laid the basis for the great Impressionist movement, Cézanne had no part; he spent his twenties (1859–69) creating imaginary scenes of wild violence and morbid eroticism that are now regarded as significant mainly because they give us an insight into the psychic turmoil he was striving to control. In their way, *The Rape, The Strangled Woman* and the like are quite extraordinary, but they represented a false start for Cézanne, and gave him a reputation as a wild man that he never completely threw off.

In the 1870s he took a new path under the guidance of Camille Pissarro, the only man to whom Cézanne ever willingly conceded the slightest authority.

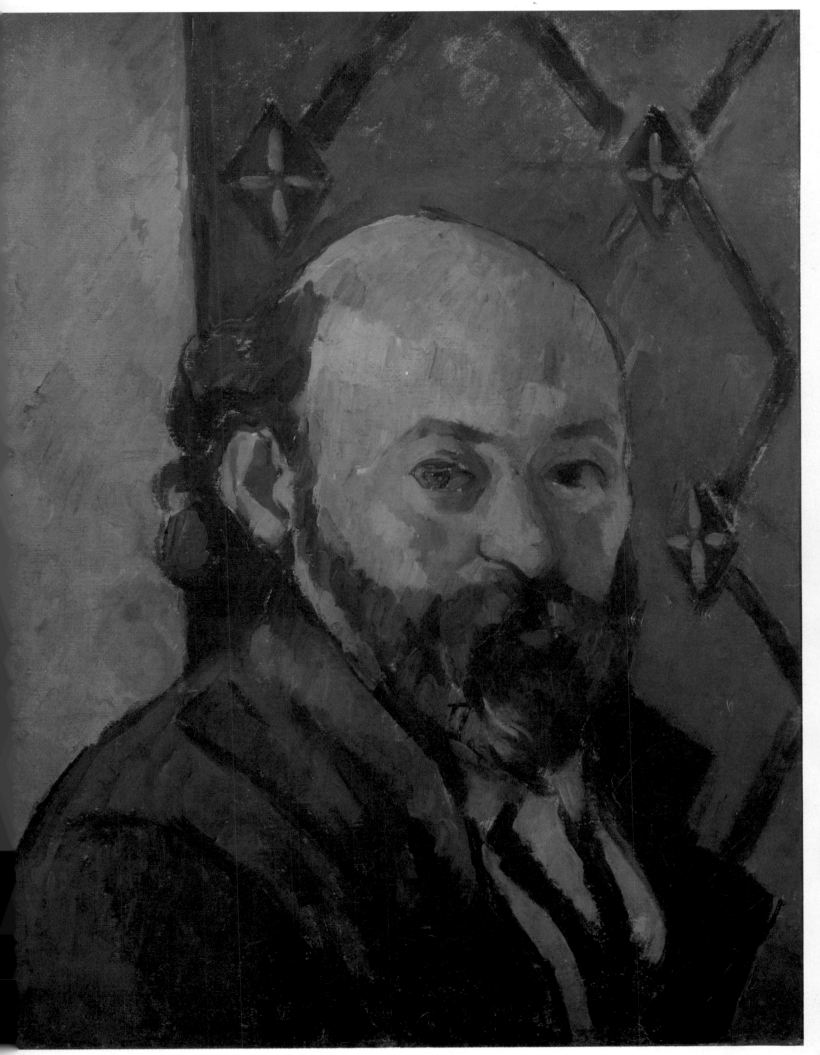

Far right: *Woman with a Coffee Pot. c.* 1890–4. Beautifully coloured yet austere in mood and construction, this painting indicates how far Cézanne had travelled from his earlier 'wild manner'. It is a sort of poem to the vertical, from the pleats in the woman's dress and the parting in her hair to the lines of the spoon and the door panels. Musée du Louvre, Paris.

Pissarro introduced him to open-air painting, and so made a belated Impressionist of him. As a result, Cézanne took part in the first Impressionist show of 1874, which introduced the movement to the public at large, and he received rather more than his fair share of the abuse hurled at the exhibitors by incensed critics. Subsequent attempts to exhibit only confirmed his ill-success, and in the 1880s and '90s Cézanne effectively gave up trying to have his work seen and appreciated in Paris. He spent more and more time in his native Provence, becoming a 'forgotten man' whom some of his contemporaries eventually assumed to have died in obscurity.

In reality he was working ceaselessly and striking out in new directions. Cézanne's experience of Impressionism proved to have been a turning-point in his development as an artist, for contact with nature steadied and disciplined him, and he never afterwards abandoned it; to the end of his life he set out almost every day, in any tolerable kind of weather, with his pack over his shoulder, eager to confront nature and capture on his canvas the sensations she aroused in him. But the Impressionists' preoccupation with ephemeral effects – the play of light, the atmospherics of a scene at a given moment – failed to satisfy him; even when most closely associated with the movement, he had shown a notable feeling for the structure and solidity of things. Later, the contrast became more marked: while his friend Monet might paint a cathedral so that it appeared to be dissolving in the sun, Cézanne would give a stretch of water the hard brilliance of marble. His aim, he once said, was 'to make of Impressionism something solid and durable, like the art of the museums', a useful if limited indication of his intentions.

In fact, his achievement went beyond a modification of Impressionism. He increasingly treated a picture as an independent entity; nature (or rather the sensation experienced by the artist in the face of nature) became the starting

Top: *The Rape. c.* 1868–70. This pencil drawing is one of many such works by Cézanne in his twenties, when he was openly fascinated by erotic violence. Kupferstichkabinett, Basel.

Above: *Woman Taken by Surprise. c.* 1870–3. Pencil drawing. Art Institute of Chicago.

Right: *Head of an Old Man. c.* 1860–5. Here, as in many of his earlier works, Cézanne laid on his paint very thickly and with emotional vigour; he often employed a palette knife rather than a brush. Musée du Louvre, Paris.

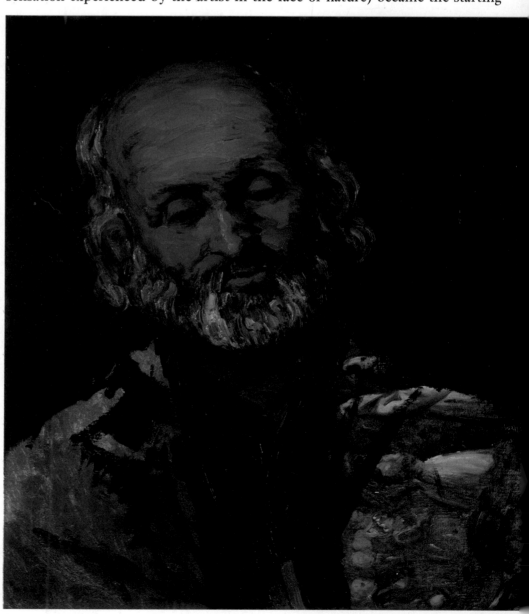

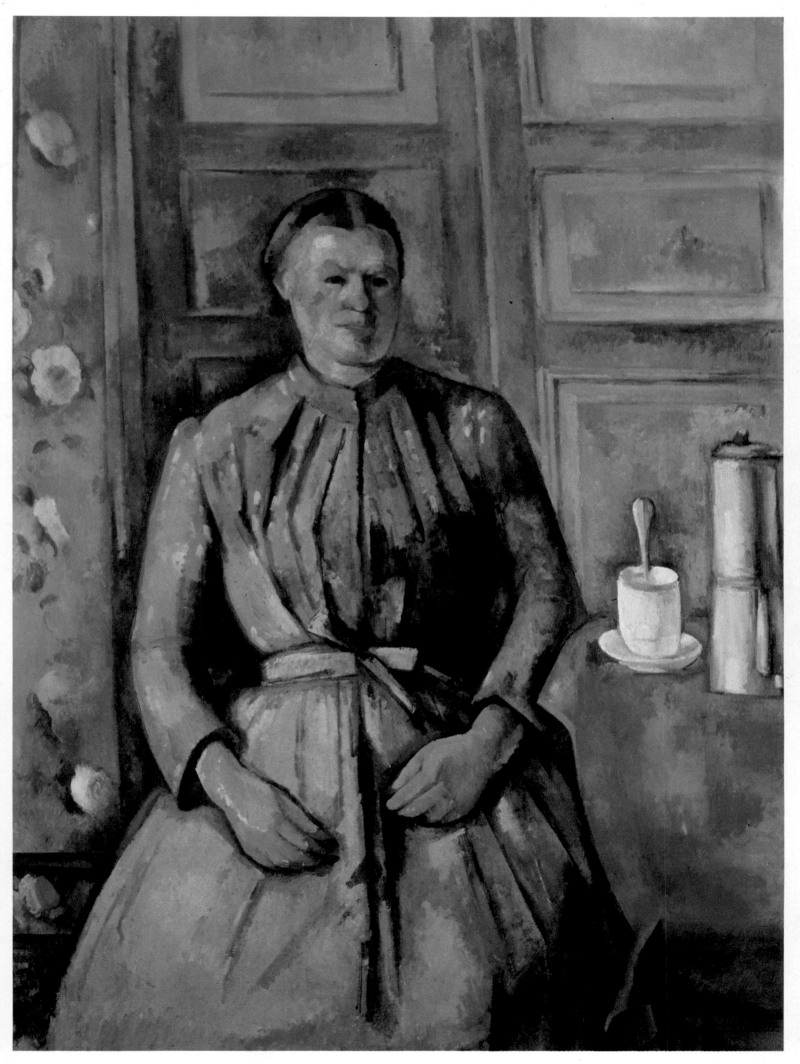

9

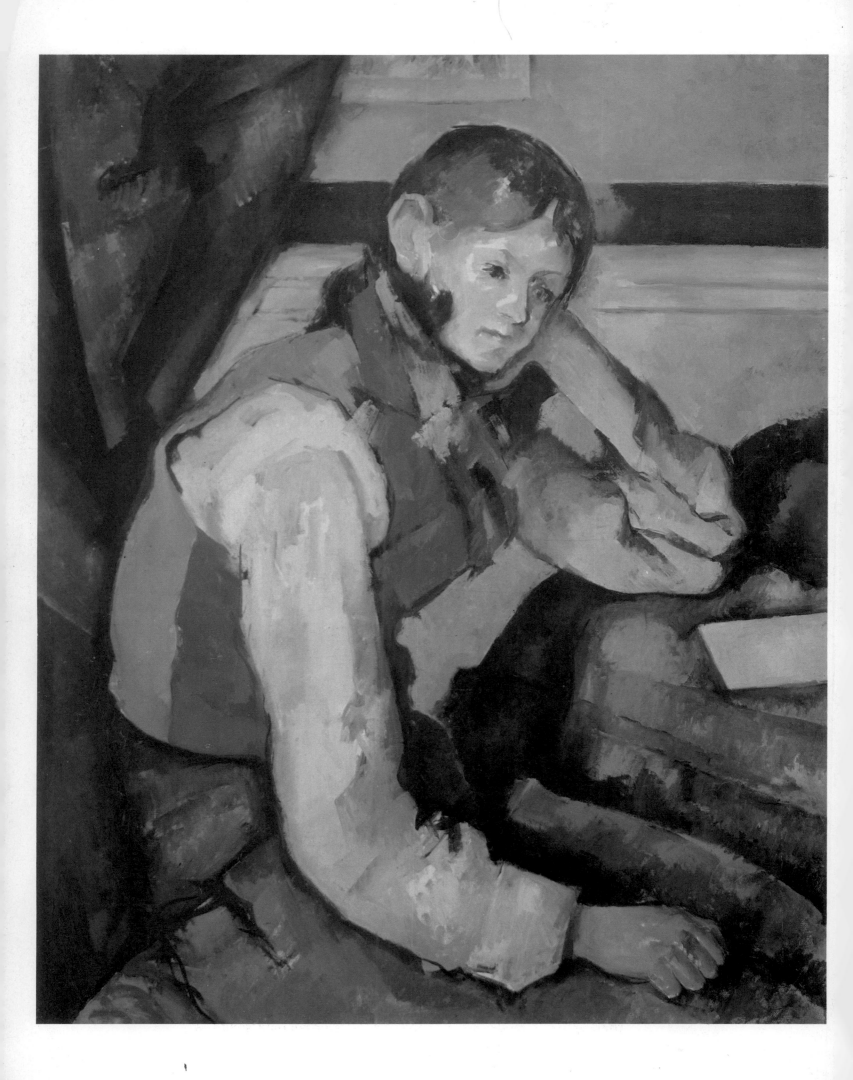

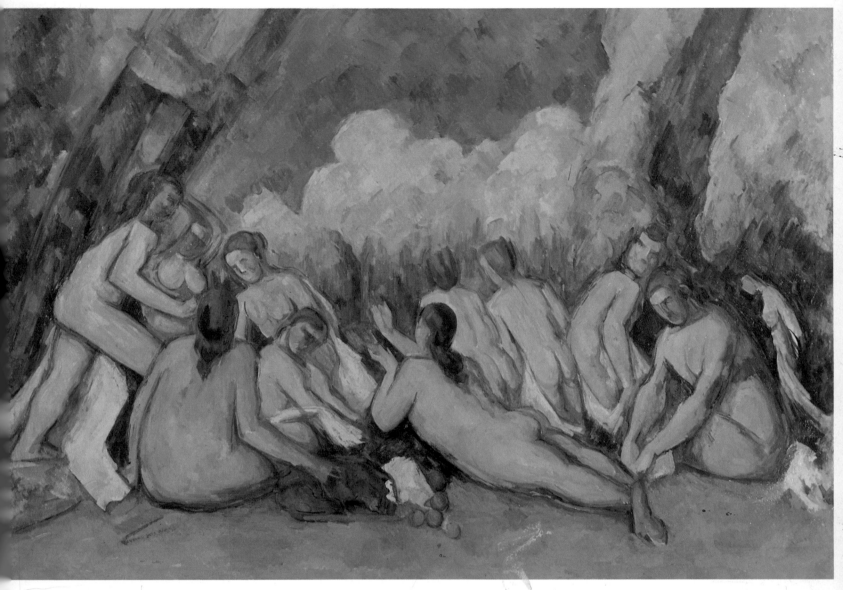

Left: *Boy in a Red Waistcoat*. 1894–5. One of Cézanne's most famous paintings; it radiates a sweetness rare in his work. The boy's elongated right arm demonstrates Cézanne's sub-ordination of realistic considera-tions to the demands of pictorial balance. Private collection, Zurich.

point for a rigorous exercise in construction and organization. It followed that the creation of 'something solid and durable' might involve an arrangement of pictorial elements that violated literal realism, as when Cézanne gave the *Boy in a Red Waistcoat* an impossibly long arm or showed a bowl of fruit from two irreconcilable points of view. In the interests of an overall design in which every element should have due prominence in terms of 'weight' and colour, Cézanne even abandoned traditional perspective (which fades and distances areas of a picture in order to give the illusion of depth) and devised his own methods of clarifying visual relations. Finally, in many outstanding works of his maturity Cézanne emphasized the unity of the picture surface by drilling his very brush-strokes into visible patterns of parallel marks. By such means he created an art of extraordinary strength, which remains related to the external world but which also insists on its rich, impenetrable, two-dimensional quality. In old age he continued to develop, painting with an increasing freedom derived from complete technical mastery; the works of this period range from cursory, wonderfully suggestive watercolours to the monumental *Great Bathers* which represent the culmination of a lifetime's obsession.

A few years before his death in 1906, Cézanne began to be recognized as a great modern master by the avant-garde artists of a younger generation; one of them, Maurice Denis, expressed their sentiments in traditional fashion by painting a *Homage to Cézanne* (1900) in which a group of admirers cluster round the great man's works. Within a few more years, before the outbreak of World War I in 1914, his paintings had begun to be accepted by the Louvre. While his artistic heirs, the Fauves and the Cubists, were ensuring that critics should continue to be outraged, Cézanne's work had become not only 'solid and durable' but also part of the revered 'art of the museums'.

Above: *Great Bathers*. c. 1900–6. National Gallery, London.

False Starts in Life

Paul Cézanne was born on the 19th of January 1839 at Aix-en-Provence, a small town a few miles from Marseilles and the southern coast of France. The South of France – the Midi – is related by geography, climate and culture to the Mediterranean world rather than to Paris and the North. Cézanne, then, was a Southerner, and his native landscape was harsh and sun-struck, a place of strong colours and hard outlines that must have exercised a potent influence on the imagination of the future painter.

The Cézanne family took its name from the village of Cesana in the Italian Alps. Having emigrated to France in the 17th century, they had worked for generations, without any particular distinction, as shoemakers, barbers and tailors. The first member to rise significantly in the world was Louis-Auguste Cézanne, the painter's father. He set up in business at Aix as a hatter, doing well in the trade and even better in the financial affairs incidental to it. Beginning with bridging loans made to breeders of the rabbits whose skins were turned into felt for Louis-Auguste's hats, he manipulated his capital so successfully that, when Aix's only bank collapsed in 1848, he was in a position to found an establishment of his own. It went from strength to strength, and by 1859 Louis-Auguste was able to show the world the extent of his wealth by purchasing the Jas de Bouffan, a large estate outside Aix centred on a splendid and historic house that had once been the country residence of a governor of Provence.

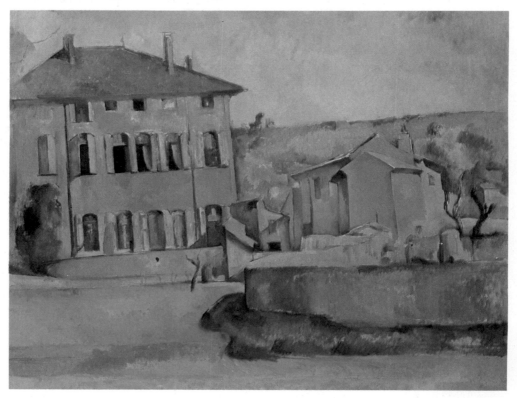

Jas de Bouffan. 1882–5. This splendid mansion became the family home in 1859, thanks to the financial ability of Cézanne's father. The style in which Cézanne has painted it shows why Picasso and other Cubists looked on him as a precursor. National Gallery, Prague.

Meanwhile, in early middle age, Louis-Auguste began a liaison with twenty-five-year-old Anne-Elisabeth-Honorine Aubert, who bore him two children, Paul (1839) and Marie (1841), before he made up his mind to marry her in 1844; a third child, Rose, was born much later, in 1854. Paul Cézanne thus grew up during a period when his father was rising to become one of Aix's leading citizens; the purchase of the Jas de Bouffan, which completed the process, took place when he was already twenty. Consciousness of being new-rich – an upstart – may have had something to do with Cézanne's later awkwardness, especially since Louis-Auguste either chose or was forced to remain outside local society,

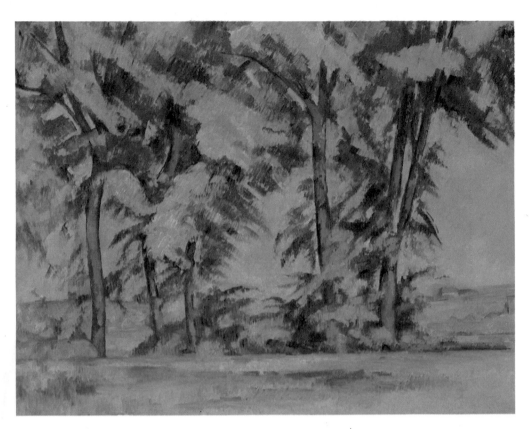

Trees at the Jas de Bouffan. 1885–7. Courtauld Institute Galleries, London.

spending his leisure hours at home where his predominance was unquestioned. He was probably something of a domestic tyrant; as we shall see, Paul remained humiliatingly dependent on his father even when he had himself become a middle-aged man.

After several years at local elementary schools, Cézanne began his secondary education in 1852 at the Collège Bourbon in Aix. He was a good scholar, and in later life continued to read the Latin classics – the staple of 19th-century education – with both ease and pleasure. He also made friends at the Collège. The most notable of these was Emile Zola, who was to become a famous novelist, describing every aspect of late 19th-century France and exposing its social evils in a cycle of works that include *Germinal, L'Assommoir* and *Nana.* That two men of such towering eminence should not only have gone to school together in a little provincial town, but should also have become close friends, was an extraordinary coincidence. Cézanne, Zola, and another gifted boy, Baptiste Baille, swore eternal friendship in the high-flown 19th-century style and formed a trio of inseparables, in and out of school. On long summer days in the country they declaimed the poetry of Victor Hugo and Alfred de Musset, composed verses of their own, bathed and fished in the little River Arc, and explored the rocky landscape with delight; these boyhood idylls remained golden memories for both Zola and Cézanne, forming an enduring bond between them. From 1858, when Zola had to leave Aix to finish his studies in Paris and then find a job, the friends kept in touch by writing long letters; these are the typical productions of intelligent adolescents, full of jokey exaggerations and sententious reflections on life. Cézanne's are crammed with verses (mostly doggerel or mock-heroic pieces about his friends); it seems that both he and Zola thought of themselves as poets, with Cézanne – according to Zola – the more gifted of the two.

Zola, as a poor young man with no solid prospects except some lowly clerical job, could legitimately dream of a literary career which might liberate and enrich him. Cézanne, clearly intended by a fierce and wealthy father for banking or one of the respectable professions, evidently felt much less confident of his destiny as an artist. True, he attended evening classes at the free local drawing academy; and when he dreamed aloud, it was of art. At twenty he fell in love with a girl called Justine, who scarcely noticed his existence and turned out to be the sweetheart of one of his friends; all the same, he told Zola, he had visions of settling in Paris with Justine, of working there in a fourth-floor studio and making himself an artist. . .

But in the meantime he dutifully went on with his studies, passing the *baccalauréat* examination at his second attempt and so qualifying for a university

course. Urged on by his father, he enrolled as a law student at Aix University. His feelings on the subject were expressed in some verses he sent to Zola:

Alas, I've taken the tortuous path of the Law
– Not taken, that's not the word, since to do it I was made!
The horrible, horrible Law, that tangled, talkers' trade
Will turn three years of my life into a frightful bore!

But although he asked Zola to make enquiries about the entrance examination to the principal art teaching academy in France, the Ecole des Beaux-Arts, he dared not confront his father with such a prospect; now and later, he seems to have believed Louis-Auguste capable of disinheriting him, while Zola's account

The Artist's Sister. c. 1867–9. Beneath his bluster, Cézanne was a timid man, and his sister Marie organized much of his life for him, especially in his old age. St. Louis Art Museum, Missouri.

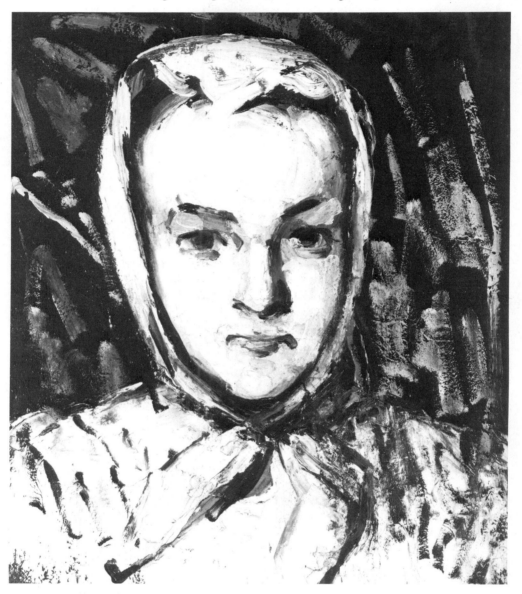

of his own poverty and loneliness in Paris cannot have encouraged Cézanne to risk the tribulations of *la vie de bohème* in an artist's garret without the assurance of regular remittances from home. Only in November 1859, after passing his first-year examinations, did he raise the question of abandoning the law for art. Once confronted, Louis-Auguste proved less of an ogre than Cézanne had imagined, half-consenting to his son's plans while fighting a long rearguard action; Zola impatiently awaited his friend's arrival in Paris throughout 1860, but it was not until April 1861 that Louis-Auguste finally allowed him to leave. Although he was twenty-two years old, his father and his sister Marie made the journey with him and stayed on in the capital for a few days while he settled in – possibly a significant indication of the light in which Paul Cézanne was regarded by his family; as we shall see, his attitude towards their protective concern (or supervision) was curiously ambivalent.

Paris, freedom and art should have been an exhilarating experience for Cézanne, even if his living allowance was no more than barely adequate. (He received 125 francs a month – a symptom of his father's enduring resolve to keep him in a state of dependence. Still, Zola was surviving on far less during this

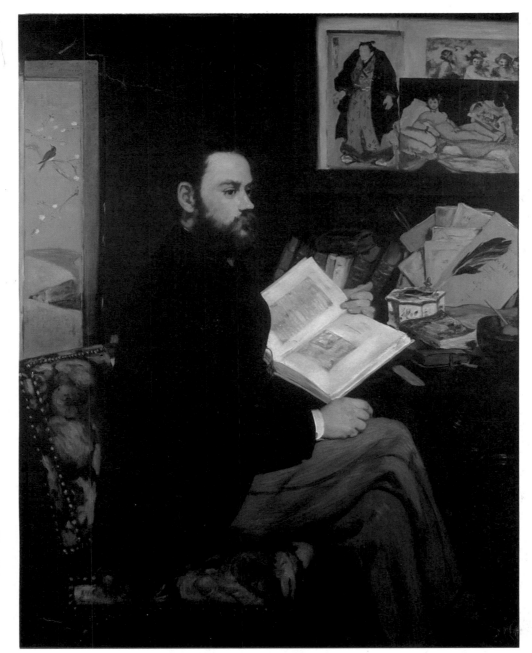

Edouard Manet. *Portrait of Emile Zola*. 1868. Zola was Cézanne's boyhood friend at Aix, and they remained close until 1886; Zola's portrait of Cézanne in one of his novels was almost certainly the cause of the rupture between them. Musée du Louvre, Paris.

period – he was out of a job – and only received 100 francs a month in the following year, when he began to work for the publisher Hachette.) Instead of exhilaration, Cézanne soon experienced depression and discouragement. Perhaps, given his sheltered provincial upbringing and the difficulty he found in mixing with other people, the bustling, outgoing spirit of the capital was simply too much for him. He enrolled at the Académie Suisse, which was not a teaching institution but simply a collective studio where, for a small subscription, artists could work from a live model. His fellow-students found him thin-skinned, despite his efforts to conceal his sensitivity behind a façade of Provençal vulgarity. He may well have been dismayed by the technical competence of these potential rivals. He was, after all, virtually untrained, and not even familiar with the historic masterpieces of art; there was little enough in Aix to indicate the heights to which a painter might aspire, and Cézanne's experience of the Louvre may have daunted rather than spurred him on. Whatever the reason, he worked with less and less confidence, constantly threatening to pack his bags and go back to Aix. With the perversity of the sufferer, he even tended to avoid Zola for long periods; then, in July 1861, Cézanne had a change of heart and began to visit his old friend regularly, although he remained as downcast as ever about his work. A few weeks later, when Zola arrived at Cézanne's studio to sit for his unfinished portrait, he found that Cézanne had destroyed the painting and was again intent upon leaving. Zola dissuaded him – not for the first time – but began to feel that his friend might, after all, be better off at home and in a different career; he concluded that even if Cézanne had the genius of a great painter, he was lacking in the genius (that is, the temperament or will-power) needed to become one.

By September 1861 it seemed that Zola was to be proved right: after five fruitless months in Paris, Cézanne threw up painting and went back to Aix.

When Cézanne thereafter bowed to the inevitable and went to work in the family bank, Louis-Auguste must have believed that his son, having had his youthful fling, would settle down to a respectable and industrious life. Even his correspondence with Zola was allowed to lapse, as if Cézanne had made up his mind to break all his links with artistic ambition. But the experience of office-work soon had a sobering effect on him, the attractions of art and Paris revived, and he was soon scribbling in one of his father's ledgers:

Banker Cézanne can't see without shaking
Behind his counter – a painter in the making.

He once more enrolled at the drawing academy, began painting in his spare time at home, and started writing to Zola. By the time the inevitable issue was raised, Louis-Auguste had probably realized for himself that his son would never make a businessman; at any rate he allowed himself to be persuaded that Paul

Left to right: *Spring, Summer, Autumn* and *Winter. c.* 1859–62. These charming, naive paintings are Cézanne's earliest surviving works, utterly uncharacteristic of his subsequent art. As a joke they are dated 1811 and signed 'Ingres', thus mocking the painter most revered by orthodox artists. Musée du Petit Palais, Paris.

deserved another chance to prove himself as a painter. In November 1862
Cézanne again left his native Provence for the capital. The events of the previous
few years had proved a series of false starts, quite unlike the vocational certainties
we associate with genius. One thing at least had been gained: even if Cézanne
was never to be really contented, never able to shake off the demons of self-
doubt, at least he had become convinced that there was no future for him outside
painting. In that sense his career had finally begun.

Up to this point his work had shown no discernable promise of genius. Among
his earliest paintings were a good many copies, either of romantic pictures in
the local museum or of engraved reproductions. More ambitious was a set of
four 10-foot-high (3-metre) canvases (c. 1859–62) representing the seasons of
the year, each personified, in traditional fashion, as a young woman. They are not
without a certain charm, but it is the charm of 'primitive' or 'naïve' art, and
Cézanne can hardly have expected to deceive anyone when he dated the paintings
'1811' and signed them 'Ingres', thus cocking a youthful snook at the master

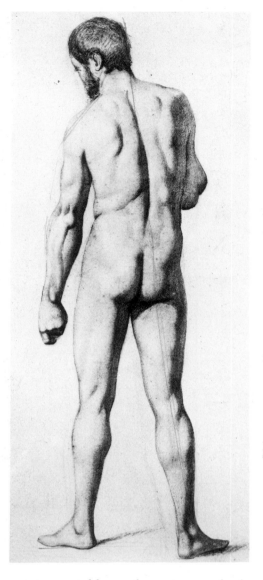

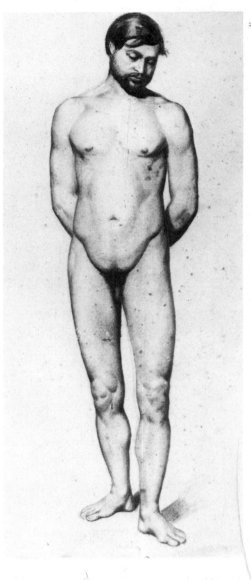

Académie: Male Nude, Back View. 1862. A pencil and black crayon drawing in impeccable academic style; these and similar studies indicate that Cézanne could have embarked on an orthodox career as student and artist if he had chosen to do so. Private collection.

Académie: Male Nude. 1862. Pencil and black crayon drawing. Musée Granet, Aix-en-Provence.

most revered by 19th-century orthodoxy. A photograph of Cézanne as a young man strongly projects his self-image as a romantic rebel with an intense gaze, flowing moustache and large silk cravat; he evidently found it expressive enough, since he used it as the basis for his first surviving self-portrait.

However, it is doubtful whether Cézanne thought of himself as an artistic rebel in any serious sense before his second assault on Paris. On his first trip, both he and Zola had dutifully admired all the then-famous, but now-forgotten masters of the day, regarding their technically accomplished but bland, 'chocolate-box' paintings as modern equivalents to the art of the Old Masters in the Louvre. The mistake was natural enough, since the arts in France were organized and institutionalized with a view to producing a consensus of practice and opinion. The Institut de France controlled all the arts; immediately subordinate to it, the Academy of Fine Arts was responsible for painting and sculpture. Since the Academy was also the regulating body for the Ecole des Beaux-Arts (School of Fine Arts) and for the annual Salon at which the 'best' works were shown, its favour was decisive at every stage of an artist's career: he depended on it for admission to the Ecole; for prizes and grants for good progress; for the privilege of being chosen to exhibit at the Salon and having his paintings well-hung at the actual show; for receiving a government decoration; and for the final accolade of admission to the Academy itself, indicating that he had arrived at the head of his profession. The artist could reach the general public only through the Salon, since one-man exhibitions and independent group shows were still unheard-of; even art dealers were virtually non-existent.

What made the situation appear entirely hopeless to the gifted but unconventional artist was the fact that the system enjoyed a wide public approval. Industrial and commercial expansion had created a predominantly middle-class market for 19th-century art; but the new buyers were less certain of their taste than their aristocratic predecessors, and were only too willing to accept 'expert' guidance. Both academicians and the general public favoured an art that was

smooth, technically accomplished and high-minded (when it was not intended to be sentimental), but unadventurous and uncontroversial; the 'picture telling a story' was immensely popular, but even the stories tended to be taken from myth and history rather than contemporary life. There were, of course, conflicting tendencies within academic art (despite the impression of universal insipidity that it now makes on us), and it was on these rather than more radical approaches to painting that public attention tended to be focused until the 1860s.

No wonder that in 1861 Cézanne, a bourgeois newly arrived from the provinces, believed the Salon to be representative of all that was best in art, a place where all styles and tastes met and clashed. His attitudes a year or so later are less easy to make out. He sat the entrance examination for the Ecole des Beaux-Arts, but failed it; he may have taken part in deference to his father, but it seems likely that he too would have been glad of official acceptance and respectability. But he never tried again, although some of his studies – drawings of male nudes that must have been made as part of his preparations for the examination – show that he might easily have been turned into a conventionally correct draughtsman. It is even possible that the unorthodox development of his art owed something to his rejection by the Ecole, although his candidacy was not the last of his efforts to secure some form of official recognition.

Cézanne must also have been influenced by his contacts with the young painters who met regularly at the Café Guerbois in the Batignolles district of Paris. The 'Batignolles group' were later to be nicknamed 'Manet's gang', after their leader in the 1860s, Edouard Manet. Neither he nor other members of the group – among them Edgar Degas, Camille Pissaro, Claude Monet, Alfred Sisley and Auguste Renoir – had yet given up hope of succeeding through the Salon, although their choices of subject and treatment were already somewhat daring. Manet, though by no means a committed realist, dared to exploit the pictorial possibilities of subjects such as *The Absinthe Drinker* (1859), which most respectable people preferred not to hear about, let alone to look at. Then in the summer of 1863, a few months after Cézanne's return to Paris, Manet became the central figure in a scandal that made him a hero to the restless younger generation. The Salon jury of that year rejected so many submissions that there was an outcry against it – not, in the main, from artistic rebels, but from perfectly conventional aspirants who felt that they had been unfairly treated. The emperor, Napoleon III, intervened, decreeing that there should be a Salon des Refusés, showing all the rejected paintings, in addition to the regular Salon; the public could then judge the situation for itself.

The Salon des Refusés proved to be a short-lived experiment, although it can be regarded as a precedent of sorts for the independent group shows that sprang up much later. It was generally felt that the Salon jury had been over-severe, but there was no violent public indignation about the matter. What *did* arouse indignation at the Refusés was Manet's *Déjeuner sur l'Herbe*, which showed a naked girl (and another girl in her shift, emerging from a stream) at lunch in the open air with two young men – young men who were not only fully dressed, but dressed in contemporary jackets and trousers. The cheerful, casual modernity of the scene was felt to be vaguely indecent; nudes were acceptable enough to 19th-century taste, and might in fact carry a powerful erotic charge, but only if, unlike Manet's, they were smoothly 'classical' in appearance, and posed against an imaginary or safely antique background.

Manet repeated the offence with his *Olympia*, which was actually accepted for the Salon of 1865 but was none the less universally abused: this nude, lolling on a bed and gazing impassively out at the spectator, was modern and disturbing, from the ribbon around her neck to the silk slipper dangling negligently from one foot; and since she was not smooth and pink and without body hair, she was, screamed the critics, 'a female gorilla', a degraded 'odalisque with a yellow belly'.

As a result of the scandals around the *Déjeuner* and *Olympia*, Manet was seen as the arch-rebel of French painting – paradoxically so, since he disliked scandal, was easily wounded by criticism, and never ceased to hope for official acceptance. Degas, who was also in his early thirties, sometimes affected to despise Manet as a timid bourgeois, but then he was undoubtedly jealous of Manet's predominance at the Café Guerbois. However, it is also true that Degas was even more thoroughly committed to 'modern life' than Manet, painting new subjects such as the racecourse and theatre; his compositional devices, influenced by the Japanese prints that artists and connoisseurs were just beginning to prize,

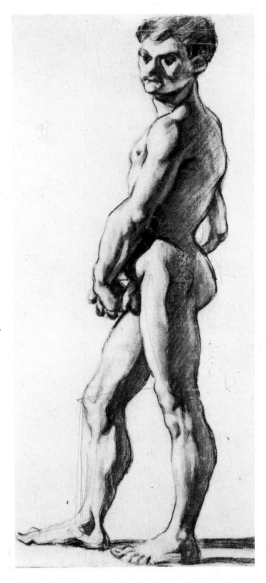

Male Nude. 1863–6. A charcoal drawing heightened with white. Fitzwilliam Museum, Cambridge.

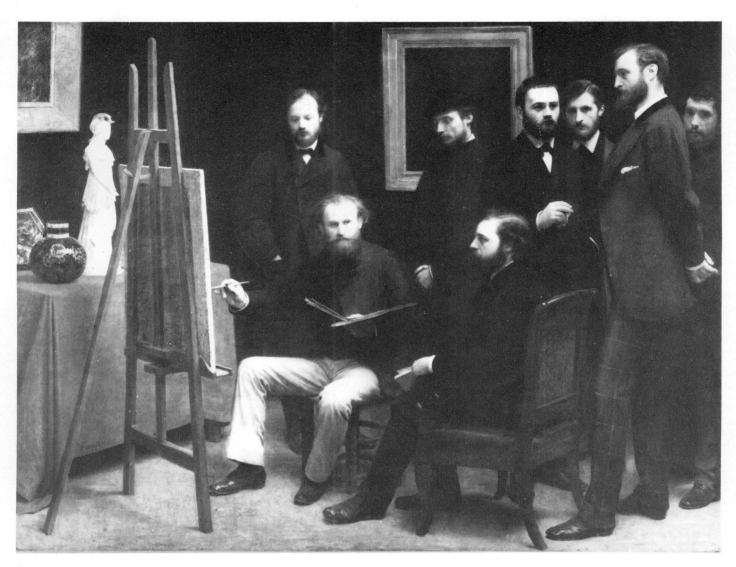

Henri Fantin-Latour. *A Studio in the Batignolles Quarter.* 1870. Also called *Homage to Manet,* and appropriately so since Manet was the leading figure among the artistic rebels of the 1860s. He is the painter here; among the admiring onlookers are Renoir and Zola in front of the painting on the wall, and Monet at the extreme right. Musée du Louvre, Paris.

gave his pictures an apparently spontaneous 'snap-shot' quality which was, in fact, achieved by unremitting labour. The younger men who frequented the Guerbois – Monet, Renoir, Sisley – were already showing great promise, but were still finding their way; their turn to shock the French public was to come a few years later. Writers who were interested in painting also appeared at the Café, among them Cézanne's friend Zola, who had published a couple of novels and was just beginning to make a name for himself as a journalist. Zola became an enthusiastic champion of Manet in particular, and was full of scorn for the Salon; from 1866, when he became literary editor of the daily *L'Evénement,* he was to be a powerful friend to new tendencies in art.

However, it seems that it was not Zola who brought Cézanne to the Café Guerbois, but Camille Pissarro, an acquaintance from the Académie Suisse. Pissarro was a little older than Manet, but had developed rather slowly (perhaps a point of sympathy between him and Cézanne); he was, and remained, essentailly a landscapist, whose eventual achievement, unspectacular but solid and subtle, has only come to be appreciated at its full value in the last few years. He was one of the very few friends that Cézanne made in adult life, thanks to a combination of benevolence, tact and breadth of mind, qualities that were to be of decisive importance in his later roles as organizer of exhibitions and teacher of younger painters. Of the other Guerbois habitués, Cézanne eventually established amicable though scarcely close relations with Monet and Renoir; the rest remained no more than acquaintances.

Inevitably, Cézanne felt ill at ease in the company, and concealed the fact by displays of eccentricity; he would sit silently through heated discussions of theory and technique – during which, no doubt, wine and good-fellowship prompted the adoption of some extreme positions – until some particularly outrageous statement made him rise from his chair and leave in a temper. Much of the time he played the provincial boor, dressing sloppily, speaking with a heavy, assumed Provençal accent, and behaving with premeditated vulgarity. Monet later recalled that on one occasion Cézanne came into the café, hitched up

his shabby trousers and, having shaken hands all round, declined to shake Manet's hand: he would not shake hands with Monsieur Manet since he, Cézanne, had not washed for eight days! As this anecdote suggests, Manet seems to have particularly irritated Cézanne. He was fasionably elegant, and a man-about-town; at the café he was a figure of authority; and, perhaps worst of all, he had created works such as the *Déjeuner sur l'Herbe* and *Olympia*, which Cézanne had permitted himself to admire (he is said to have called *Olympia* 'the beginning of our Renaissance'). By the 1860s, Cézanne had developed an intensely suspicious attitude towards other people, believing himself in dire peril of being influenced or interfered with; the feeling eventually became so morbid that he could not bear to be touched. In reality he continued to be at the mercy of a

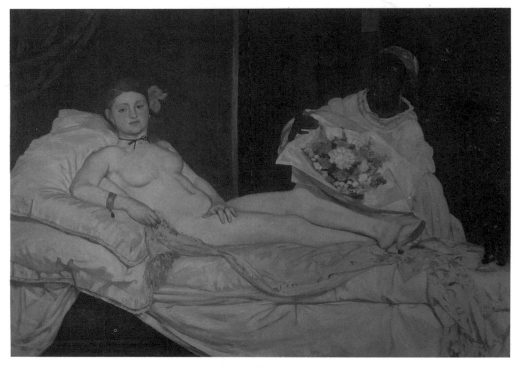

Edouard Manet. *Olympia*. 1863. The scandal of the 1865 Salon, this painting sounded a modern note that most people regarded as simply improper. Cézanne disliked and perhaps even envied Manet; his *Modern Olympia* (page 41) is a ribald parody. Musée du Louvre, Paris.

father who held the purse-strings and, it seems, took it as his right to open any letter addressed to his grown-up son; in art, at least, Cézanne could flaunt his independence, going his own way with an over-insistence that served to conceal his inner uncertainties.

There was a similar ambivalence in his behaviour towards the established system. Much of the work he produced was genuinely unconventional and shocking in 19th-century terms – more overtly violent and erotic than any canvas by Delacroix, the great Romantic painter of the previous generation. Yet, year after year, Cézanne submitted examples of his work to the Salon jury, just like any other ambitious young man; and when, year after year, the jury decided that they were not good enough to be included in the show, he was as disappointed and angry as any other young man. In April 1866 he was so exasperated by the rejection of two of his canvases that he wrote two letters of protest to Count Nieuwerkerke, the Superintendant of the Fine Arts. Characteristically, he made a show of boldly repudiating the jury's authority (which he had implicitly acknowledged by submitting his works in the first place), and asked for the establishment of a new Salon des Refusés so that the public might be allowed to judge for themselves; he proclaimed that, if necessary, he would be prepared to be the sole exhibitor in such a show. The authorities turned down his request, and Cézanne continued to submit – and to be rejected – as before. However, Cézanne was not merely a rebel who longed to be accepted; his case was more complicated. Even as he placed his paintings before the Salon jury, he made a point of behaving in a fashion that seemed calculated to secure their rejection: he gave the pictures offensive names, and ostentatiously delivered them, in a cart, at the last possible moment allowed before the submissions list closed. As early as 1865 he was boasting to Pissarro that his canvases would 'make the Institut blush with rage and despair'; and the arrogant tone of his letter to Nieuwerkerke must have confirmed his reputation as a wild man. Clearly Cézanne was engaged in performing a elaborate psychic balancing act which enabled him to cope with the failures he probably felt to be inevitable.

The Romantic Cézanne

Cézanne's paintings of the 1860s indicate just how precarious his psychic balance must have been. In the light of their erotic violence and frightening intensity, his oddities and outbursts in ordinary life seem quite mild – mild as the occasional blasts of gas and ash which signal the existence of a volcano that has never (yet) erupted. The delirious voluptuousness of the naked women in paintings such as *The Temptation of St. Anthony* (*c.* 1867–69) and *The Orgy* (*c.* 1864–68) represents an extraordinary confession on the part of Cézanne, a man who in real life found the very presence of a nude model intensely upsetting. Like the hero of Zola's novel *The Masterpiece* (*L'Oeuvre,* 1886) who was clearly based on Cézanne, he was chaste and yet experienced 'a passion for female flesh, an insane love of nakedness desired yet never possessed; he found it impossible to satisy himself, impossible to create as much of this flesh as he dreamed of holding in his frantic arms. The girls whom he drove out of his studio, he adored in his paintings . . .' This of course states the paradox but does nothing to help us resolve it. No doubt there was more to it than a passion for the flesh, which Cézanne might have satisfied easily enough. He kept his own counsel and, except in his paintings, chose to contain rather than indulge his drives – appalled, perhaps, by something in their nature and intensity that made release unthinkable. His self-suppression was so effective and successful that the precise nature of his psychic malady is never likely to be more than a matter for idle psychoanalytical speculation.

The element of unbridled sexual fantasy is made apparent in St. Anthony's tormentors, with their ample, rippling flesh and vast, highlighted buttocks. In other paintings, a morbid preoccupation with violence and death is expressed with equivalent force. There is an insistence in *The Autopsy* (1867–69) on the butcher-like aspect of a pathologist's work: he seems to be plunging his powerful bared arms deep into the dead man's viscera. (Actually this is an illusion: Cézanne places the pathologist's hands behind the corpse, suggesting rather than showing the messiness of the operation.) The pathologist, a large bald man with a beard, might easily be Cézanne himself; and indeed the painter's occasional presence in his works is another indication of his deep emotional involvement with the subjects he was painting at this time. *The Murder* (1867–70) is a still more violent scene, showing a woman holding down the hapless victim while her male accomplice raises his knife, ready to plunge it home. A linking of sexual and violent urges, often implicit in the mood of many paintings by Cézanne, is made overt in *The Rape* (1867), although there is some concession to 19th-century sensibilities in that – as in *The Autopsy* and *The Murder* – a rupturing of the flesh is suggested but not in fact shown.

Study for *The Orgy*. *c.* 1864–8. Kupferstich-kabinett, Basel.

Male Nude. Study for *The Autopsy*. *c.* 1865. Art Institute of Chicago (Margaret Day Blake Collection).

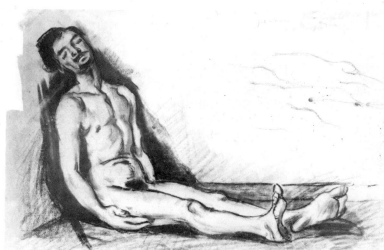

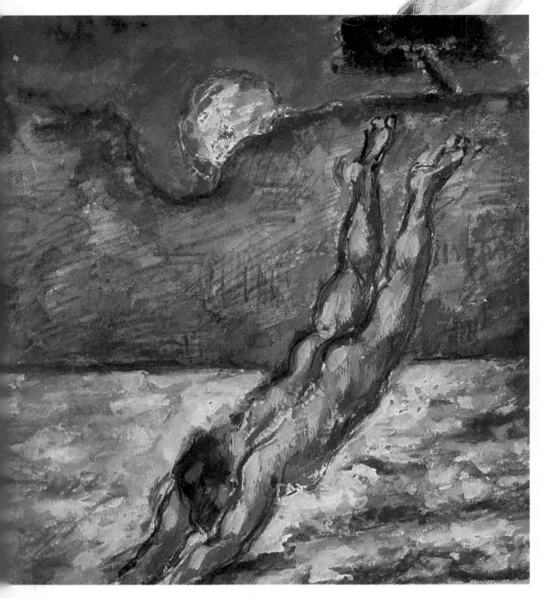

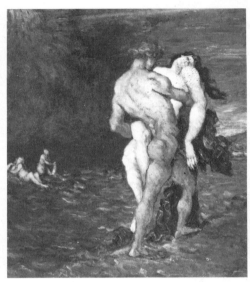

Left: *Bather Diving into Water*. 1865–70.
National Museum of Wales, Cardiff.

L'Enlèvement (detail). 1867. Trustees of
the late Lord Keynes.

bitter or sardonic about them: he began one of his letters to Pissarro, 'My dear friend: Here I am with my family, with the most disgusting people in the world, those who compose my family stinking more than any.' All the same, he spent months at a time in close proximity to the 'stinking' people, working in his studio at the Jas de Bouffan. The family circle must therefore have had its attractions, if only as a cheap place to live and a refuge from the outside world.

Cézanne's family and friends supplied the subjects for almost all his early portraits. These are in many respects closer to his mature works than to the romantic-morbid fantasies; they already have a characteristic impersonality, a calm monumentality, and a concern for the careful arrangement of masses – even at the expense of literal realism – that are absent from the orgies and rapes that preoccupied another part of his personality. One of his most frequent subjects (painted four times at least) was his Uncle Dominique, portrayed variously in a turban-like indoor hat and as a white-robed monk; his large, bearded, severe figure is reminiscent of the self-portraits of Cézanne himself in middle life. Whatever his reservations about his son's choice of career, Louis-Auguste Cézanne also sat for his portrait. (There is no certain surviving portrait of Cézanne's mother, although she is generally supposed to have been his ally in family conflicts.) Cézanne's best painting of his father shows the old man (*c.* 1866) in his armchair reading *L'Evénement* – presumably a compliment to its literary editor, Paul Cézanne's great friend Emile Zola, who used its columns to attack the artistic establishment. The subsequent progress of Zola's career is also reflected in Cézanne's paintings, which emphasize his role as literary lion (e.g., *Paul Alexis Reading to Zola*, 1869–70). Other portraits – of Anthony Valabrègue, Gustave Boyer, Achille Empéraire – confirm that Cézanne continued to feel most at home with friends he had known since boyhood and fellow-citizens of Aix; for example, there are no equivalent portraits painted by Cézanne of the Batignolles group.

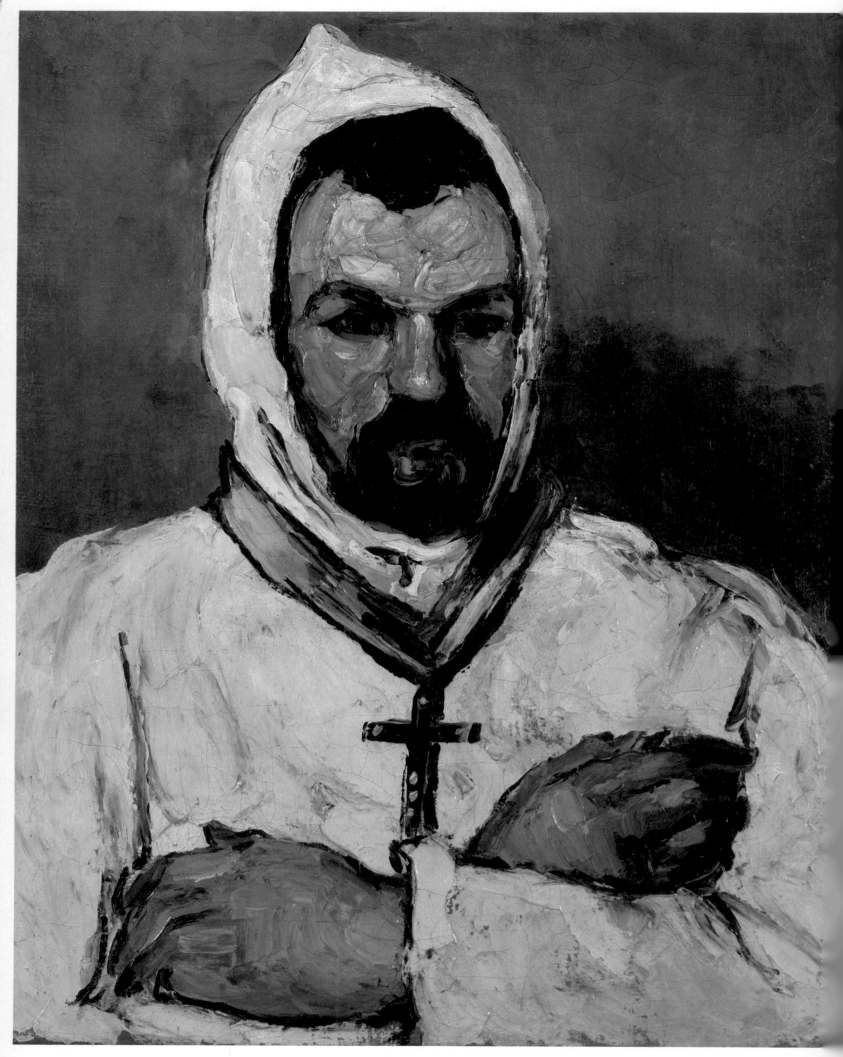

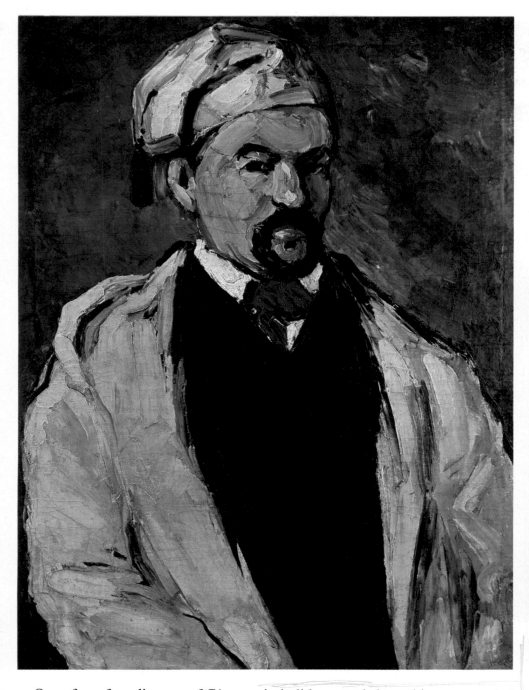

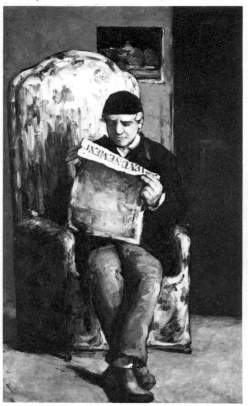

Far left: *Portrait of Uncle Dominique as a Monk. c.* 1865–7. Cézanne's timid and irritable nature made him dependent on family and friends for human subjects. He painted his Uncle Dominique on several occasions. Collection of Mrs Enid A. Haupt.

Left: *Man in a Blue Cap. c.* 1865–6. The subject is Cézanne's Uncle Dominique. Metropolitan Museum of Art, New York.

Above: *Portrait of the Artist's Father Reading 'L'Evènement'. c.* 1866–8. Cézanne was dominated by his father to an extent unusual even among 19th-century middle-class sons with expectations; even when the painter was in his fortieth year he dared not confess the existence of his mistress (later Madame Cézanne) and their little son. National Gallery of Art, Washington, D.C. (Collection of Mr. and Mrs. Paul Mellon).

One of our few glimpses of Cézanne in holiday mood shows him surrounded by Southerners, albeit far from home. He spent the summer of 1866 at Bennecourt, a village on the Seine not far from Nantes, in the company of Baptiste Baille, Valabrègue and various artist-friends from Aix such as Philippe Solari and Jean-Baptiste Chaillan, now remembered only for their connection with Cézanne. Zola, who paid a number of visits to Bennecourt, has left lively descriptions of the writers and artists there, stretched out of an evening on the straw spread over the courtyard of the inn, keeping the peasants awake with their heated disputes about romanticism and realism. This picture provides a necessary reminder that Cézanne – whom it is easy to visualize as always surly and fierce – was still only a young man, capable of naïve enthusiasms. At this time, Zola wrote to a friend that he had great hopes for Cézanne, who was painting vast canvases at Bennecourt – canvases that no doubt appealed to Zola's taste for the epic scale, but which Cézanne presumably later destroyed or abandoned, since nothing of the sort has survived.

The early works that most closely anticipate his later development were his still-life paintings. Few of his contemporaries showed more than a passing interest in this genre; painting a group of inanimate objects had little appeal except as a form of practice in the acquisition of a meticulous technique. For Cézanne, with his growing conviction that a painting should not reproduce reality but re-order it, still life had a special attraction in that the 'model' itself could be arranged and re-arranged according to the artist's will. However, in the 1860s he rarely achieved the tranquil, impersonal quality of his later still lifes;

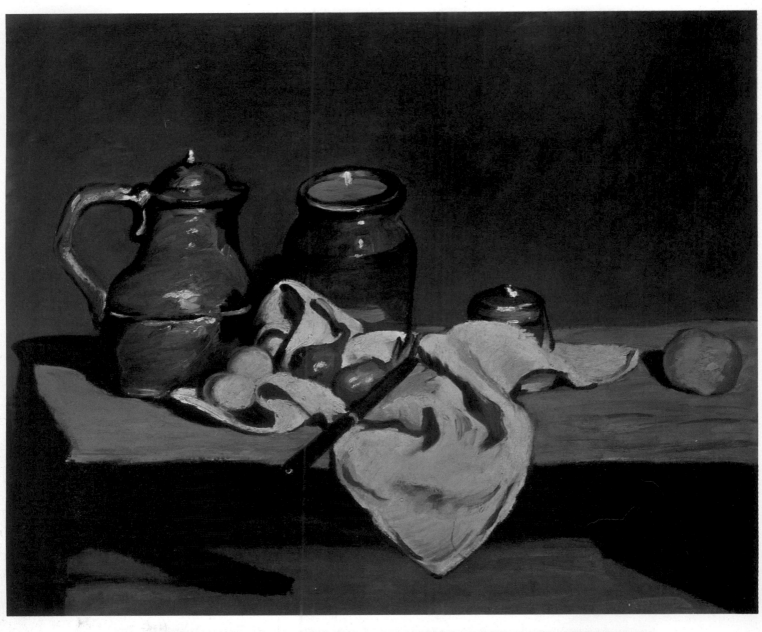

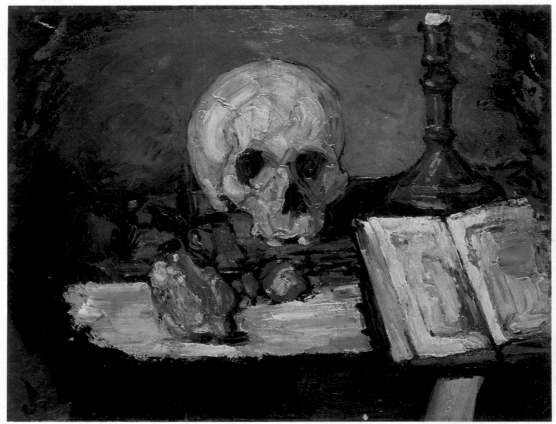

Left: *Still Life with Coffee Pot. c.* 1870. Long neglected, the still life was restored to a central place in painting by Cézanne. Here his style, though rather heavy, owes much to the 18th-century master Chardin. Musée du Louvre, Paris.

Below left: *Still Life with Skull and Candlestick.* 1865-7. The agitated style and sinister properties distinguish this sharply from Cézanne's later still lifes. Private collection. Zurich.

a picture such as *Still Life with a Jar and Coffee Pot* (*c.* 1870; Musée du Louvre, Paris), which owes a good deal to the previous great master of the genre, the 18th-century artist Jean-Baptiste Chardin, is the exception. *Still Life with Skull and Candlestick* (1865–67) is more characteristic in its emotionalism, combining romantic properties – the skull and candlestick – with Cézanne's violent palette-knife handling of the paint. Even *The Black Clock* (1869–71; Niarchos Collection), perhaps the best of the early still lifes, has an underlying sinister quality. The clock, shell, cup and other objects on the table are organized in an impressively firm and solid design; yet – the clock has no hands, and the shell has a great red gash of a mouth which gives it an obscenely predatory look. Both *Still Life with Skull and Candlestick* and *The Black Clock* could pass as illustrations for a tale by Edgar Allan Poe.

Until he was over thirty, the main characteristic of Cézanne's art was an extreme emotional violence that contemporaries found unpalatable; when one of his paintings was put on show in Marseilles (presumably he was hoping to sell it), there was some danger that an infuriated public might destroy it. The 'expert' Salon juries were equally unfriendly although, as we have seen, Cézanne often went out of his way to provoke them. As late as 1870 he submitted a *Portrait of Achille Empéraire* (painted about 1868) that he must have known would shock and offend. It is a large painting, executed mainly in oppressive

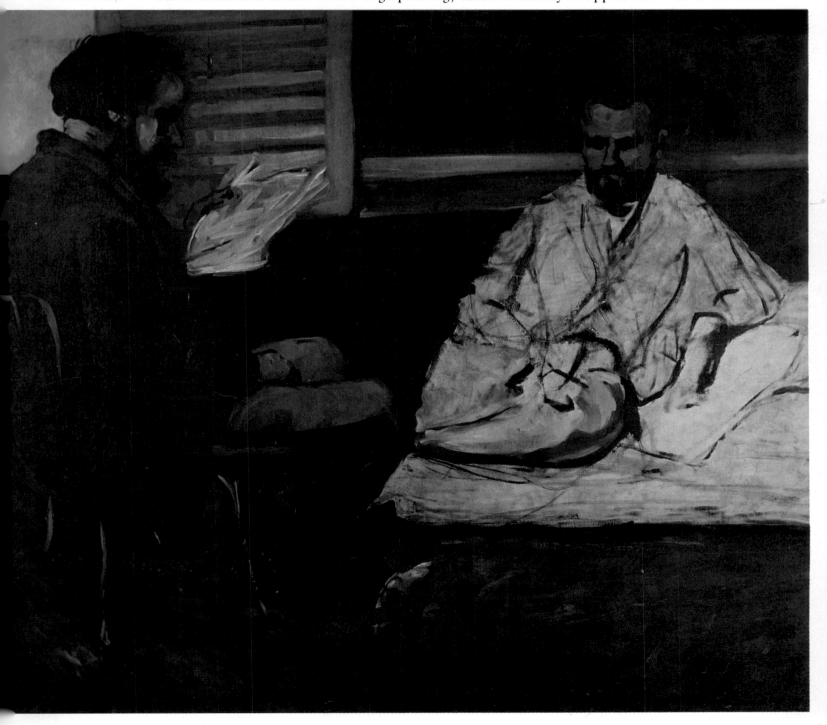

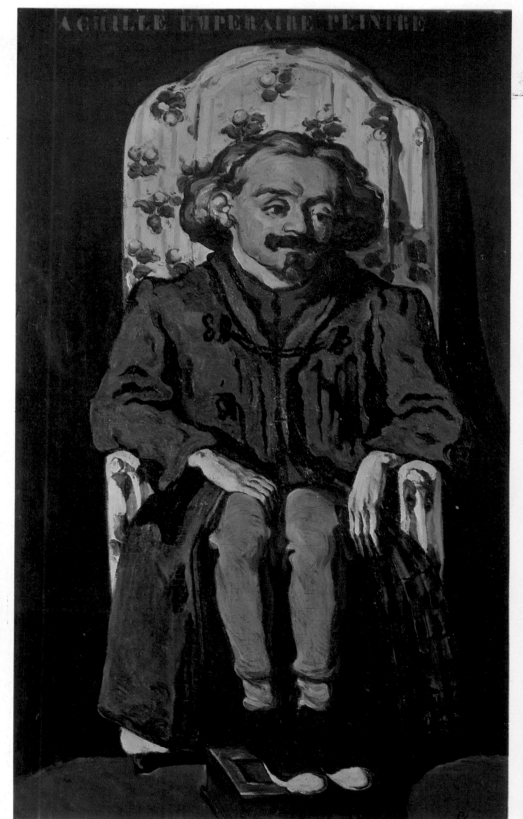

Right: *Portrait of Achille Empéraire.* 1868. Empéraire was Cézanne's friend, a fellow citizen of Aix, and an impoverished painter. Cézanne submitted the portrait to the 1870 Salon, although he must have known that such an extraordinary conception had no chance of acceptance. Musée du Louvre, Paris.

Above: *Portrait of Achille Empéraire.* 1867–70. Charcoal and pencil drawing heightened with white. Cabinet des Desseins, Musée du Louvre, Paris.

greenish tones, that even today makes a curious impression on the spectator. The distorted little figure of Empéraire (who was in reality crippled) is seated like a child, with knees together and feet resting on a box, in a high throne-like seat; as if to emphasize the naïveté of the treatment, Cézanne painted in capitals at the top of the canvas the words 'Achille Empéraire, Painter'. As a matter of fact, this portrait brought Cézanne fame of a sort – or rather notoriety: together with another painting submitted to the Salon (a reclining nude), it was found singular enough to be made the subject of a newspaper cartoon in which a benignly crazy-looking Cézanne appears with the offending items.

Towards the close of the 1860s, his friends may well have believed that Cézanne was a confirmed 'wild man', in an impasse of eccentricity. Within a very short time, however, both his life and his art were to undergo decisive changes.

The Impressionist Experience

In 1869, while staying in Paris, Cézanne met a nineteen-year-old seamstress called Hortense Fiquet. They became lovers and companions and, many years later, husband and wife. As far as we know, this was Cézanne's first and only liaison of any long-term significance; but its influence on his art and life is problematic. Unfortunately, Hortense is a shadowy figure. If Cézanne ever wrote to her, his letters have not survived, and in others he refers to her only in uninformatively conventional terms. He painted her many, many times, but Cézanne's portraits, to an even greater extent than those of other painters, tell us less about the sitter than about the artist. She is generally supposed to have been dull and perhaps even rather foolish, although the evidence for this view is insubstantial (she liked Switzerland and found Aix boring). Perhaps it was only the fact that she bore Cézanne a son – Paul, born in 1872 – that kept the couple together. Cézanne did eventually revert to his solitary habits, sometimes spending months separated from Hortense and Paul; all the same, even a limited domesticity must have had some normalizing influence on him, and perhaps contributed to the new direction his art was to take in the 1870s.

Portrait of Madame Cézanne in Blue. 1885–7. Museum of Fine Arts, Houston, Texas.

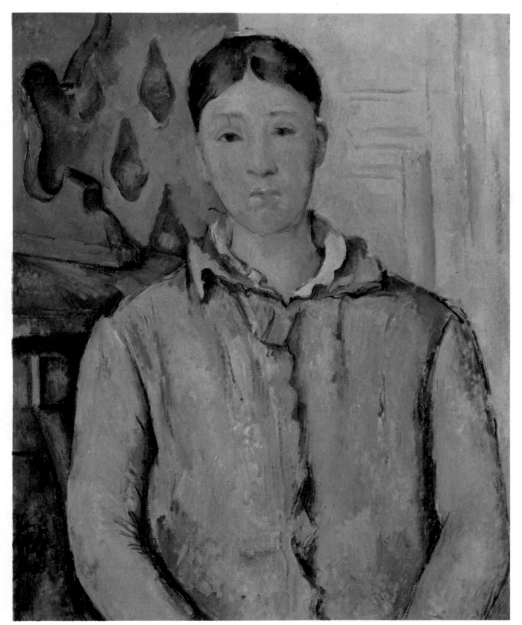

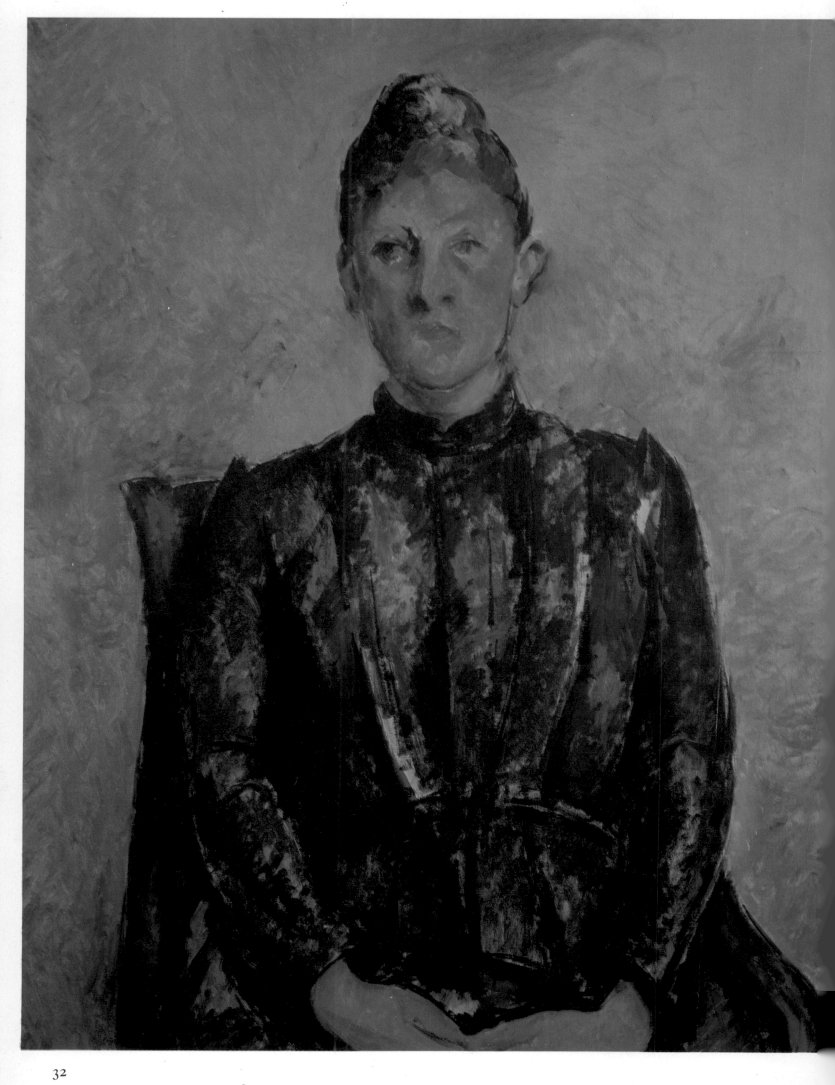

Cézanne concealed from his father the very existence of Hortense, and later of little Paul; he evidently feared disinheritance or at least a cessation of his allowance to bring him to heel. Although Cézanne does seem to have been unusually fearful of his father, the situation was not uncommon among the propertied classes; Manet, for example, found himself in a similar position, marrying only after the death of his parents. The 19th-century patriarch had plenty of opportunities to play the tyrant if he felt the inclination, and we have seen that Louis-Auguste Cézanne kept his son on a tight financial rein. Cézanne himself remarked with irony on his 'excellent' family's meanness, which he pretended to think a slight and excusable fault in the provinces! Here and elsewhere Cézanne seems to use 'family' as a euphemism for 'father'; his mother was in on the secret of Hortense and Paul and could be relied on to let friends such as Zola know the whereabouts of the illicit pair.

For the first few years of his liaison with Hortense – presumably when the relationship was at its most passionate – Cézanne spent very little time at Aix. But he continued to visit the South. The summer of 1870 found him not far away from Aix, at L'Estaque, a village on the Mediterranean coast just outside Marseilles. On this occasion he was hiding from the authorities as well as from his father: war had broken out, and men of Cézanne's age were being conscripted into the army. This conflict was the Franco-Prussian War of 1870–71, begun by the French emperor, Napoleon III, in an attempt to combat the growing power of Bismarck's Prussia. The outcome was a disaster for France: the Emperor was captured, the armies were routed or capitulated, the Bonaparte dynasty was swept away, and a new French Republic – the third – was born in the midst of defeat and civil war. In Paris, besieged for five months by the Prussians, people queued to buy cat-, dog- and even rat-meat to keep hunger at bay; then, after the French surrender, a revolutionary government, the Commune, briefly controlled the capital until, after another siege, government troops stormed the city and drowned the revolt in blood.

Manet, Degas, Renoir and Zola were all in Paris during at least some of these events; Cézanne, like Pissaro and Monet (who spent most of the war in London), kept well out of the way. Pissarro and Monet may have been influenced by political motives (neither was enamoured of the Bonapartes), but Cézanne appears to have been completely indifferent to public events, consciously living in a kind of internal exile. His life and work can therefore be approached without the detailed descriptions of the historical and social background that are necessary in the case of many artists; only the history of art itself has any real

Left: *Portrait of Madame Cézanne*. 1885–90. Musée du Louvre, Paris.

Two pencil studies of Cézanne's son Paul. *c.* 1877. Art Institute of Chicago.

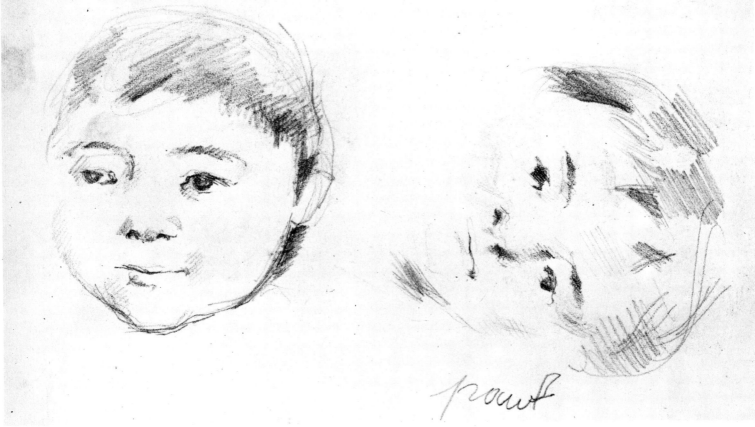

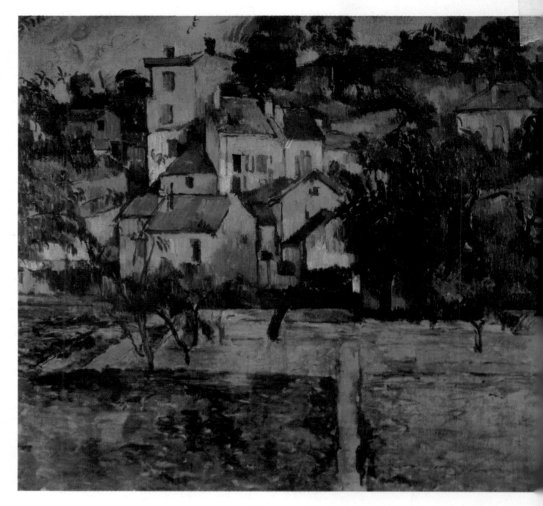

Right: *The Hermitage, Pontoise*. 1875–7.
This view of Pontoise, done only three
years after Cézanne's 'conversion' to
Impressionism, shows his feeling for
structure reasserting itself in emphatic
geometric forms. Von der Heydt Museum
der Stadt, Wuppertal.

Above: *Landscape at L'Estaque*. 1870–2.
Pencil drawing. Art Institute of Chicago.

relevance to his life. Whereas Zola's career would be incomprehensible to
someone with no knowledge of the building of the great boulevards, the scandals
and corruption in high society, the war or, later, the Dreyfus case, none of
these touched Cézanne's life in any important way. Only the war made any kind
of impact, but that only in the negative sense that it dissuaded him from leaving
L'Estaque for some considerable time.

Cézanne's paintings of L'Estaque in 1870 show the beginnings of a new
approach to his work: through contact with nature, through the attempt to
capture the essence of the visible world, he achieved a new discipline and
balance. Painting in front of nature did not involve an abandonment of subjec-
tivity, but did result in a creative interaction between artist and reality that
proved more valuable for Cézanne than the unbridled subjectivity of his
previous work. He continued to paint violent, imaginative fantasies from time
to time, but with decreasing frequency; the various *Bathers* canvases of his
later years are clearly related to this side of his personality, but their mood is
quite different, as if purged of violence by their creator's long immersion in the
natural world.

Cézanne stayed at L'Estaque with Hortense until the summer of 1871, when
it was safe to return to Paris; his son Paul was born at lodgings in the Rue
Jussieu on 4 January 1872. Three months later, sick of Paris but unable to go
back to Aix with Hortense and Paul, Cézanne accepted an invitation to join his
old friend Camille Pissarro who lived at Pontoise, a quiet little town not far from
Paris, in the Oise valley.

Cézanne spent two years in close contact with Pissarro, living first at Pontoise
and later, from January 1873, in the nearby village of Auvers. As we have seen,
Pissarro's qualities and inclinations made him an ideal teacher, whose influence
extended over two generations or more; Cézanne was merely his most can-
tankerous disciple. Alfred Sisley had worked with Pissarro at Louveciennes in
1870, and in 1872–74 several other artists painted side by side with Pissarro and
Cézanne, notably Armand Guillaumin, a minor Impressionist whom Cézanne
had met during his early days at the Académie Suisse, and the now less well-
known Edouard Béliard. A few years later, Pissarro helped yet another artist of
genius, Paul Gauguin, who was to become most famous as the painter of a
mythicized Polynesian life. Cézanne and Gauguin – both difficult characters –

spoke of Pissarro with reverence (*almost* always) in later life. 'He was my master and I do not deny him,' wrote Gauguin; Cézanne called him 'the humble and colossal Pissarro' and 'a man something like the Lord God'. Pissarro did not, of course, give lessons in any conventional sense, but simply worked side by side with his younger friends, influencing them by his practice and occasional comments in discussions. Much of his authority stemmed from an open-mindedness that made him eager to learn as well as to teach, and from an absolute respect for every fellow-artist's distinctive sensibility or temperament; it was this, the artist's unique 'sensation', that Pissarro regarded as the ultimate source of any value a creative work might possess.

Pissarro, Cézanne and the others tramped about the countryside in most weathers; drawings and photographs show them with broad-brimmed hats and high boots, shouldering their packs with the practised ease of modern hikers. Natural though this seems to us, it was still rather eccentric behaviour by the standards of the 1870s, when gentlemen were expected to be well turned-out on all occasions. To a man such as Cézanne's *bête noire*, Count Nieuwerkerke, the

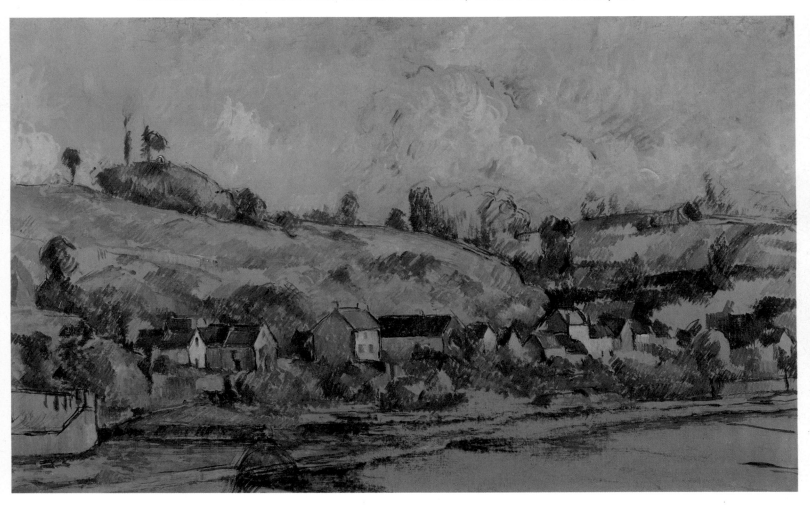

Auvers from the Harmé Valley.
1879–82.
Kunsthaus, Zurich.

open-air painter had something of the revolutionary about him. The Count remarked of an earlier generation of landscapists, 'This is the painting of democrats, of people who don't change their linen and want to put themselves above men of the world. This art displeases and disquiets me.' The *Portrait of Paul Cézanne*, painted by Pissarro in 1874, would have confirmed all Nieuwerkerke's prejudices, showing the banker's son, scowling and bearish, in a cap and rough greatcoat that made him look more like a trapper or lumberjack than the 19th-century idea of a gentleman-artist. To some extent, then, social prejudice reinforced aesthetic disapproval of the kind of painting produced by those working out of doors.

All the same, direct confrontation with nature, and preoccupation with effects of light and atmosphere, had become hallmarks of avant-garde painting by the 1870s. Pissarro, Monet, Renoir and Sisley had pioneered it, more or less consistently, in the 1860s; Manet, though essentially an urban dandy and the creator of an elegant, consciously 'composed' art, painted many fresh beach and riverside scenes between 1869 and about 1875. Cézanne, belatedly, abandoned romantic introspection and took Pissarro as his mentor. Degas alone of the

Batignolles group – whom we can now usefully start to call the Impressionists – remained convinced that good work could only be done in the studio, and suggested that the activities of itinerant painters should be brought to the attention of the gendarmerie.

Curiously enough, Cézanne had presented the case for the superior freshness and immediacy of open-air painting as early as October 1866. In a letter to Zola, he had remarked that 'pictures painted inside, in the studio, will never be as good as those done outside . . . I shall have to make up my mind only to do things out-of-doors.' The strange aspect of this impeccably Impressionist statement is that it was never followed up: if Cézanne succeeded in finishing any landscapes in 1866, they have not survived, and he did not continue with the experiment but worked for the rest of the 1860s along the lines already described. His 'Impressionism' was a false start, perhaps representing a brief experiment suggested by the work of his friend Pissarro. Later, in 1870, it may well have been Pissarro's influence again that prompted Cézanne to paint his first land-

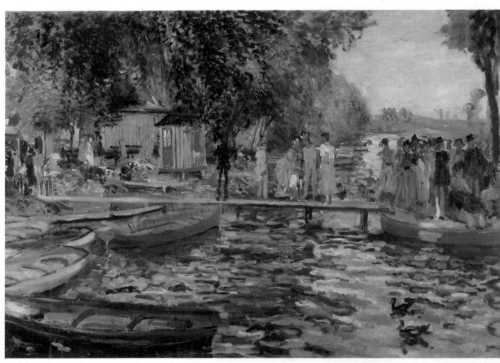

Right: Auguste Renoir. *La Grenouillère*. 1869. The distinctive Impressionist technique was pioneered by Renoir and Monet in the summer of 1869 at a popular resort on the River Seine. The brilliant colours and sharply evoked atmospheric effects constituted a revolution in painting. Oskar Reinhart Collection, 'Am Romerholz', Winterthur.

Below: *Pissarro Going off to Paint*. 1874–7. A pencil sketch of the master who introduced Cézanne to Impressionist technique. The outdoor painter was very much a beast of burden (and not quite respectable), lumbering about the countryside with his equipment strapped to his back. Cabinet des Desseins, Musée du Louvre, Paris.

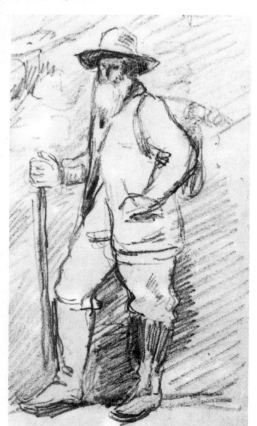

scapes at L'Estaque; the relative absence of dark colours from these works seems very much like a response to Pissarro's advice.

By the time Cézanne joined Pissarro at Pontoise in 1872, the techniques of rapid on-the-spot painting had been greatly refined and improved. Given the way in which ideas are exchanged and modified within a group of like-minded artists, it is impossible to establish exactly who discovered a particular technique, but it seems beyond doubt that the biggest single breakthrough was made by Monet and Renoir in the summer of 1869; working side-by-side in and around the suburban resort of Bougival on the Seine, they created the earliest paintings of the distinctively Impressionist type – scenes of pleasurable activity in a natural setting alive with light and movement. Their version of nature was brighter than almost anything seen before in the 19th century; by comparison, the pictures of 'revolutionary' landscapists of previous years – Daubigny, Théodore Rousseau, Courbet – seemed dull, because they lacked the crucial presence of light and air. The most startling technical innovation made by Monet and Renoir was to paint with small brush-strokes of pure colour; orthodox practice was to mix colours on the palette and apply them in long strokes, carefully fused to create a smooth surface. The new method of broken brush-work had the practical advantage of favouring rapid execution, which was essential if the atmosphere of a given place and time of day was to be captured. Its artistic justification was the bright, vibrant effect created by the juxtaposition of pure colours, which were automatically blended by the eye (a process known as 'optical mixture') as soon as the picture was viewed from a short distance away.

To most contemporaries this method of painting seemed scandalously negligent; they were amazed and angered by paintings that looked like 'meaningless' masses of blobs when the spectator brought his eye close up to the canvas.

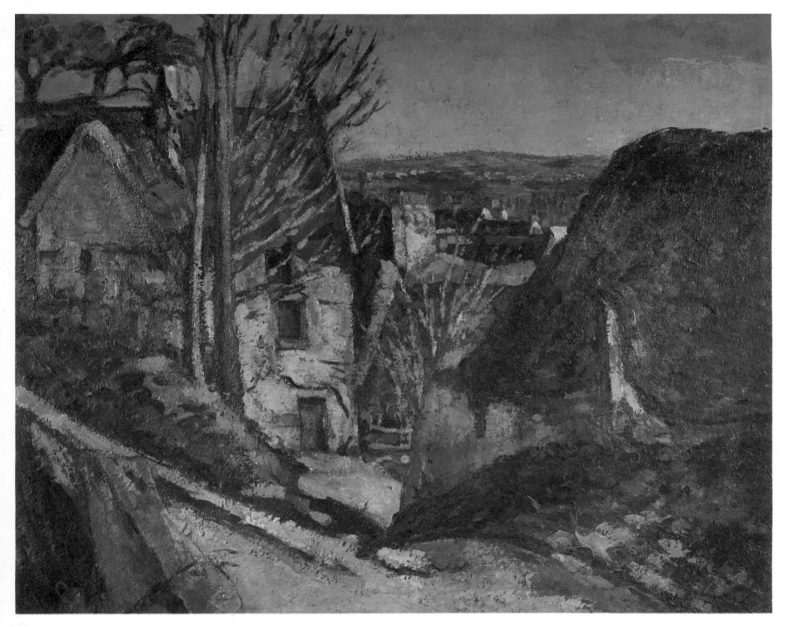

The House of the Hanged Man. 1872–3. One of the finest canvases from Cézanne's Impressionist period. Impressionism transformed Cézanne's painting, and marks the beginning of his lifelong commitment to painting from nature; but even here he is obviously more preoccupied with the solidity of things than, say, Renoir in the painting on the opposite page. Musée du Louvre, Paris.

Educated within a particular convention, critics and public saw the 'sketchiness' of the execution – the blobs, the details left out, the rough surfaces – and missed both the light-filled atmosphere created by Impressionist colour and the sense of movement given by the dance of the brush-strokes. The Impressionists also challenged conventional modes of seeing: instead of painting shadows black and conveying the effects of light through careful gradation of tones, they used their broken brush-work to put in the varied elements of colour that exist everywhere in nature except on strongly lit and shadowless surfaces – the tinge of green in the shadow cast by a leaf, modified by the colour of the flesh it falls upon, the proximity of a red chair and so on. Contemporary critics such as the influential Albert Wolff could make nothing of all this; in 1876, after seeing one of Renoir's superb nudes, her blooming skin dappled and shadowed in the sunlight, he was moved to write, 'Try to explain to M. Renoir that a woman's torso is not a mass of rotting flesh covered with violet-green spots . . .'

Through Camille Pissarro, Cézanne gained access to the pooled techniques and observations of what came to be called the Impressionists. Without any show of false pride he set himself to learn, dutifully copying Pissarro's *View of Louveciennes* to obtain a better idea of how the older man achieved his effects. In short order, the colours of Cézanne's palette grew brighter and his brush-strokes smaller; the melodramatic self-projections of the 1860s gave way almost entirely to an art that was apparently impersonal. (There is no such thing as completely impersonal art, of course, but the mature Cézanne would probably have applauded the novelist Flaubert's remark that the artist should exist in his work like God in his creation, omnipresent but invisible.) What could not have been predicted was the extent and rapidity of Cézanne's advance in Pissarro's company: paintings such as *The House of the Hanged Man* (1872–73)

37

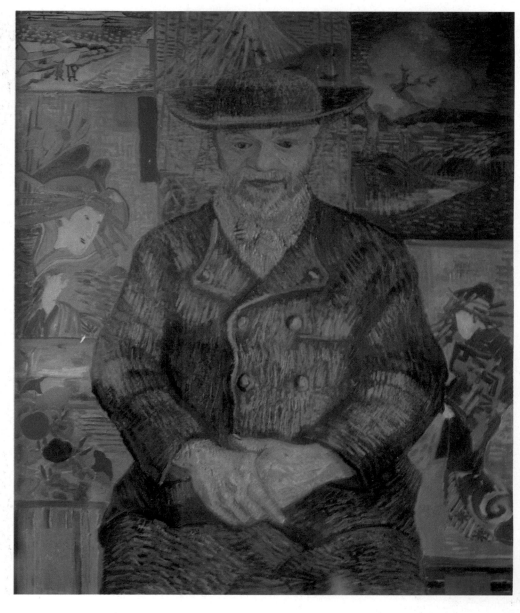

Vincent van Gogh. *Portrait of Père Tanguy*. 1887. The paint merchant Père Tanguy was one of the few people to appreciate Cézanne's paintings. He later also helped the Dutch artist Van Gogh, who painted him here against a background of Japanese prints. Musée Rodin, Paris.

Right: *The House of Dr Gachet at Auvers. c.* 1873. Musée du Louvre, Paris.

and *The House of Père Lacroix* (1873) are not the works of a tyro Impressionist but unmistakable masterpieces, with a stamp of authority and control, utterly different from anything he had done before.

There can never be any really satisfactory explanation of such a swift and intense blossoming of genius; it is only possible to pick out contributary causes rather than identify the activating experience, let alone the source and nature of genius itself. The stabilizing effect of painting from nature was evidently one contributory cause of Cézanne's maturation; another must have been the influ-ene of Pissarro as a friend and supporter as well as a teacher. Pissarro believed in Cézanne's genius and stood up for him at a time when even the other Impressionists, remembering him as the 'wild man' who painted rapes and murders, regarded him as a liability to their cause. For Cézanne, highly insecure behind his gruffness and fits of bluster, the genuine confidence in him expressed by Pissarro must have been invaluable.

One of the few people who shared Pissarro's opinion of Cézanne was the paint merchant and picture-fancier Père Tanguy, who occupies an honourable place in the history of modern art. Tanguy had fought for the revolutionary Commune of 1871, and had known prison and exile before returning to France and starting his business. It was modest enough – a little shop in the Rue Clauzel whose takings were supplemented by Tanguy's earnings as an itinerant paint salesman. A humble and apparently commonplace man, Tanguy seems to have had a near-infallible instinct for good painting, gladly exchanging his materials for canvases that pleased him but which might remain unsold in his back room for years. Having befriended the earlier Impressionists, he recognized Cézanne's genius when the painter was introduced to him by Pissaro; later still, in the 1880s, he helped the struggling Dutch artist Vincent van Gogh, who conferred a well-deserved immortality on the old man by painting three portraits of him.

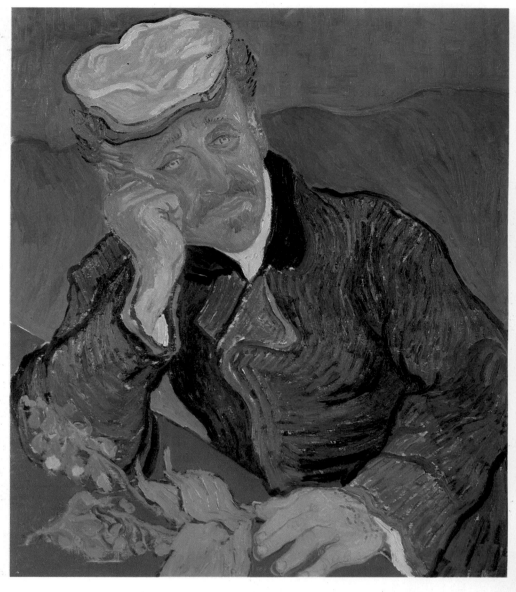

Vincent van Gogh. *Portrait of Dr Gachet*. 1890. Gachet was a friend of Cézanne's, and *A Modern Olympia* (opposite) was painted in his house. But it was a later protégé of Gachet's, Van Gogh, who painted his portrait with 'the sorrowful expression of our time'. Musée du Louvre, Paris.

Tanguy performed two important services for Cézanne: he gave him credit and bought his canvases. The credit was badly needed; if Cézanne had found it difficult to live on his allowance as a single man, his connection with Hortense and Paul made it quite impossible in the 1870s. Besides, painting was an expensive art to practise (in this, at least, Zola had the advantage of Cézanne). Tanguy extended credit liberally and over an astonishingly long term, as we know from a letter he wrote to Cézanne indicating that a bill for 2,174 francs (almost eighteen months' allowance for the younger Cézanne!) had been owing since at least 1878, and remained unpaid in 1885. Cézanne's ultimate reputation also owed something to Tanguy, who acquired many of his paintings. He was even less successful in selling them than he had been with works by other unconventional artists, and the famous back room always housed a good selection of Cézannes. In fact Tanguy's became the only place in Paris where Cézanne's works could be seen, a fact of increasing importance in the 1880s and '90s, when Cézanne himself had virtually retired to the distant south. Younger painters who heard rumours about his work were able to see examples at Tanguy's which persuaded them to make contact with the hermit of Aix; and it was largely thanks to this that he acquired a following and was an influence in his old age.

Cézanne made one other helpful friend during his years of close association with Pissarro. At Auvers he met the eccentric Dr. Paul Gachet, an amateur artist whose beautiful house, overlooking the valley, features in several of Cézanne's paintings. Professionally, Gachet was a reputable physician, but in private he was a committed crank; he seems to have been an indiscriminate advocate of any idea that offended his contemporaries, ranging from phrenology to free love. However, his taste for opposition served him well in artistic matters, since it led him to frequent the Café Guerbois and to collect works by Pissarro, Renoir and other Impressionists. Like Tanguy, Gachet gave Cézanne practical

A Modern Olympia. 1872–3. A curious, quirky variation on Manet's *Olympia* (page 21). The painting seems to have obsessed Cézanne, who made several such 'modern' versions of it. Musée du Louvre, Paris.

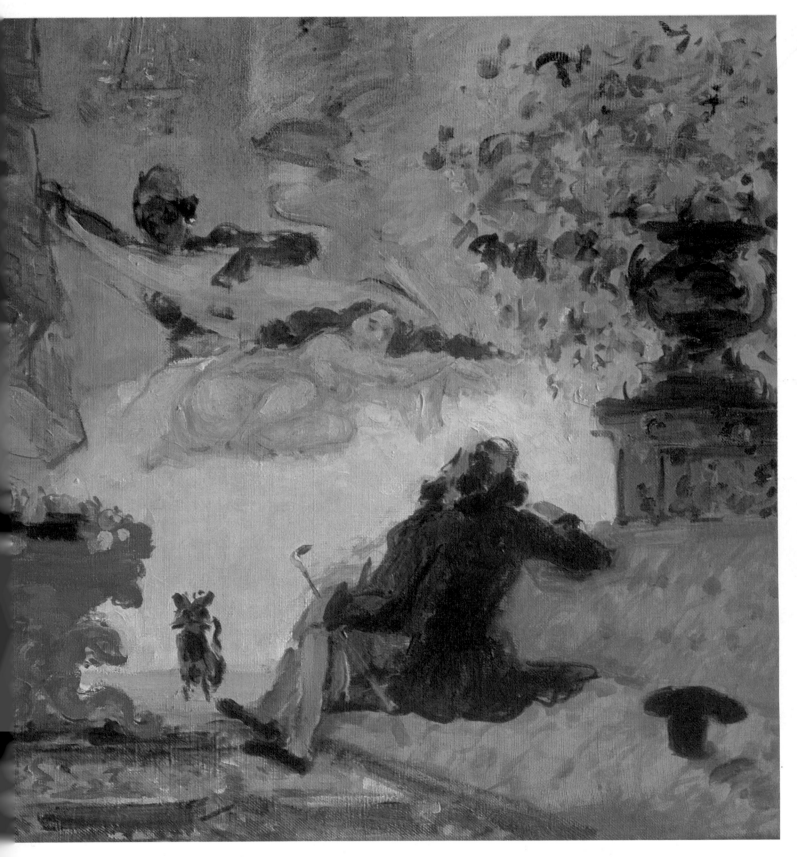

as well as artistic support. He was Cézanne's first patron, buying several still lifes of flowers and fruit (picked from Gachet's own garden) and also the notorious *Modern Olympia*, which will be discussed later at some length. He persuaded the local grocer – one of several tradesmen with whom Cézanne had run up a large bill – to accept paintings in lieu of cash. And he even managed to convince Louis-Auguste Cézanne, whom Gachet had actually known many years earlier, that his son's monthly allowance should be increased to 200 francs. A minor but interesting service of Gachet's was to let Cézanne use the etching equipment he kept in his studio. (Etching is a form of printmaking, using a copper plate into which the artist's design is cut with acid.) The two etchings Cézanne executed at Gachet's house were the only prints he ever made: one was a portrait of his painting companion Armand Guillaumin, the other a copy of

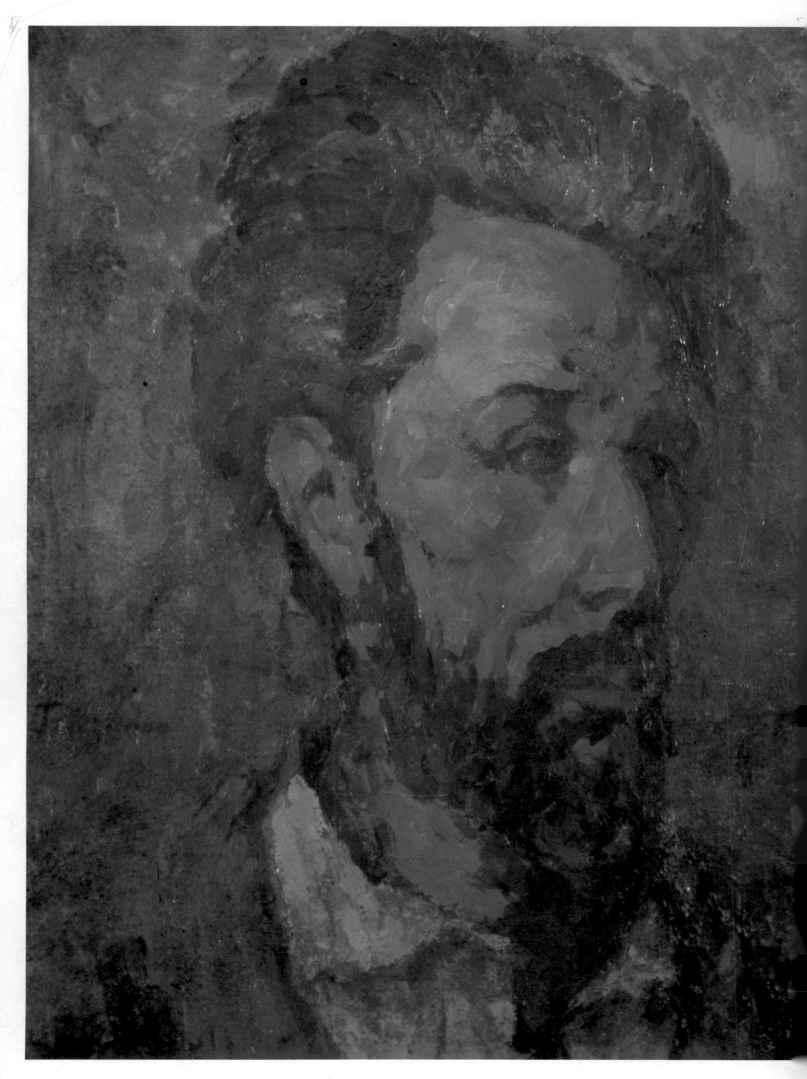

Left: *Portrait of Victor Chocquet. c. 1876–7.* Chocquet was the first person to collect Cézanne's work on any scale. This impressive portrait was unusual at this period in that its subject was not part of Cézanne's family circle. Private collection.

Self-portrait. 1875–6. Pencil drawing. Art Institute of Chicago.

Guillaumin's *View over the Seine*. By an odd coincidence, Gachet, like Tanguy, was never painted by Cézanne but twice sat for Van Gogh, who was under the doctor's supervision in the last, painful months of his life. His *Portrait of Dr. Gachet* gives the subject what Van Gogh called 'the sorrowful expression of our time' but seems also to have been an excellent likeness, showing the physician's shocking saffron-dyed hair beneath a white cap which, together with a blue jacket, he wore as a sort of uniform.

During the immediate post-war period (1871–73), France experienced an economic boom from which even 'avant-garde' artists benefited, mainly thanks to the speculative buying policy of the dealer Paul Durand-Ruel, who acquired a large stock of Impressionist works. The Impressionists themselves were active and optimistic, in close touch and conscious of making important advances; while Pissarro and his friends painted around Pontoise, Monet, Renoir, Sisley and later Manet worked together at Argenteuil, a riverside resort only a dozen miles or so away. In such an atmosphere it seemed feasible to challenge the Salon, which remained largely hostile to the new art, by organizing an independent group exhibition. This was a momentous decision: apart from a couple of defiant one-man shows by Courbet and Manet, and the occasional revival of the Salon des Refusés, there had been nothing quite like it before. Manet, who had never been a rebel by temperament, disapproved and refused to exhibit, although his woman painter-friend Berthe Morisot joined Degas, Monet, Renoir, Sisley, Pissarro, Cézanne and twenty-three others in this show by 'The Anonymous Cooperative Society of Painters, Sculptors, Engravers, etc.', which opened its doors to the public on 15 April 1874. Not all the exhibitors were Impressionists, and indeed Degas, who had been among the most active organizers, regarded the occasion as a 'realist Salon'. But with the exception of Degas's own, unclassifiable work, the outstanding paintings were by the artists listed above, whom we now call Impressionists. The name came about because

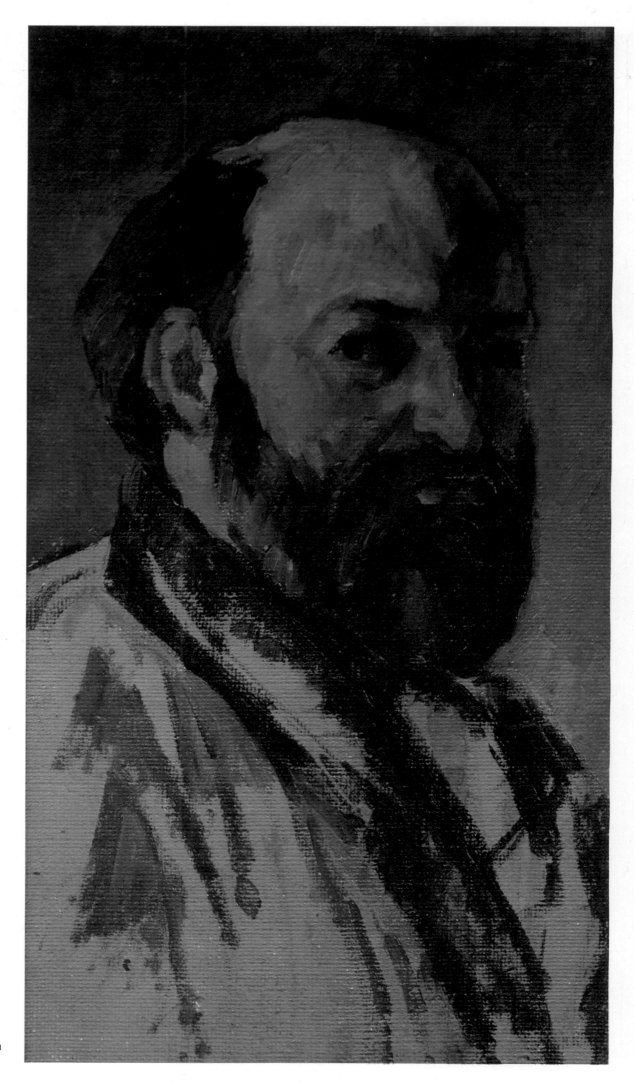

Self-portrait.
1877—80. Musée du
Louvre, Paris.

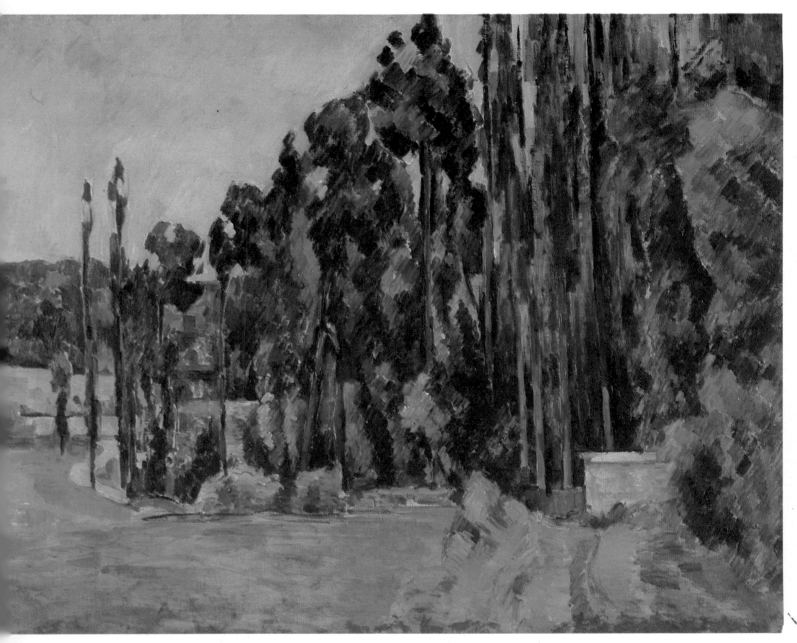

Poplars. c. 1879–80. Musée du Louvre, Paris.

one of the critics who went to the show, a certain Louis Leroy, found the exhibitors distinguished – by their ludicrous incompetence. Taking his cue from Monet's *Impression: Sunrise*, Leroy sprinkled his article in the periodical *Charivari* with gibes about 'impressions' (that is, sloppy, half-finished daubs) and fixed the name 'Impressionists' on the group as a whole, which most of them were soon perfectly willing to use of themselves with no intention of self-disparagement. Leroy was only the most scathingly inventive of the hostile critics, whose lead was followed by the general public. It must have seemed that Impressionism would be swept away in a torrent of laughter.

Cézanne's exhibits were abused as vigorously as any – more vigorously, perhaps, than most. He had been admitted to the 'Anonymous Cooperative Society' with reluctance, on Pissarro's insistence, and showed only three works: *The House of the Hanged Man, Auvers Landscape* (1873) and *A Modern Olympia* (1872–73). The first two were splendid Impressionist landscapes, and therefore attracted a certain derision; *A Modern Olympia* was closer to his earlier frenzied manner, and caused one of the great scandals of the exhibition. It appears that Cézanne had painted a version of Manet's *Olympia* and this had given rise to an argument about Manet between himself and Dr. Gachet. (One would dearly like to have overheard an argument between those two strange beings!) As a result, Cézanne painted *A Modern Olympia* in Gachet's house, and the amiable doctor bought it. The picture parodies Manet's cool original in content as well as treatment: instead of carrying a bouquet, the attendant Negress is unveiling 'Olympia' with a theatrical flourish; Olympia herself has become pink and ample to the point of grossness; and the unseen visitor on the threshold of the boudoir in Manet's picture – that is, you or I – has materialized into a burly,

balding man-about-town with a suspicious likeness to Paul Cézanne, casually seated on an ottoman while he watches the striptease. As these and other details indicate, the picture is a joke – perhaps a little silly, perhaps in bad taste by 19th-century standards, but surely harmless enough; it is not large and, as the slashing, nervous brush-work indicates, was probably dashed off with ferocious jollity in a single session. The fact that it outraged people, and was even thought to be in danger of physical violence, speaks volumes for 19th-century prudery, and also for the extent to which the arts were regarded as solemn, necessarily uplifting pursuits. Painting was an Art, and since the *Modern Olympia* plainly did not merit the capital letter, its creator was, as one writer put it, a kind of madman who painted in a state of delirium tremens; yet as a newspaper cartoon the picture would probably have been well received as a timely comment on modernity in painting.

A Modern Olympia confirmed Cézanne's 'wild man' reputation, which journalists exploited in a familiar fashion, provoking intemperate outbursts from him that made excellent copy. He was evidently disturbed by the general hostility (despite his usual disclaimers) and, shortly after the exhibition closed in mid-May, he fled back home to Aix, leaving Hortense and his little son behind. Characteristically, he was soon to be found on the attack again, attempting to outrage provincial orthodoxy. He showed the curator of Aix Museum – his old drawing-master, Guibert – a number of his paintings, gleefully remarking that their offensiveness was as nothing by comparison with the doings of the 'great criminals' in Paris such as Pissarro; but the curator seems to have disappointed Cézanne by becoming only mildly scandalized. Cézanne returned to Paris in the late summer of 1874; the South had begun to reassert its hold on him, but for some years yet he spent considerable periods in or near the capital.

If the 1874 exhibition had been a public failure, it none the less won the Impressionists some new supporters; Cézanne's *House of the Hanged Man,* for example, was bought by Count Armand Doria for 300 francs. The other Impressionists needed such windfalls more than Cézanne did; he was to some extent protected from the rigours of the later '70s by the allowance he received,

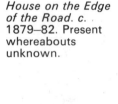

House on the Edge of the Road. c. 1879–82. Present whereabouts unknown.

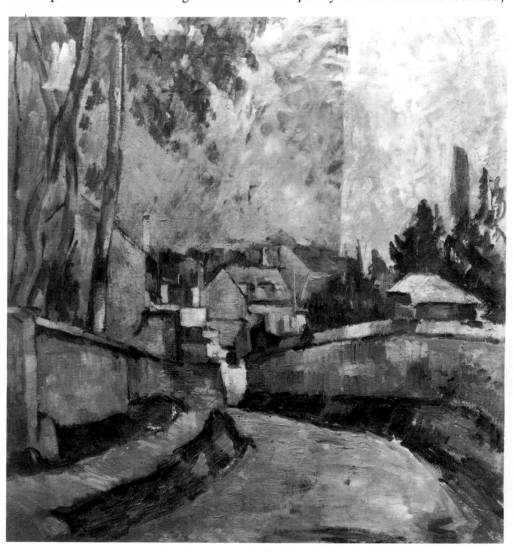

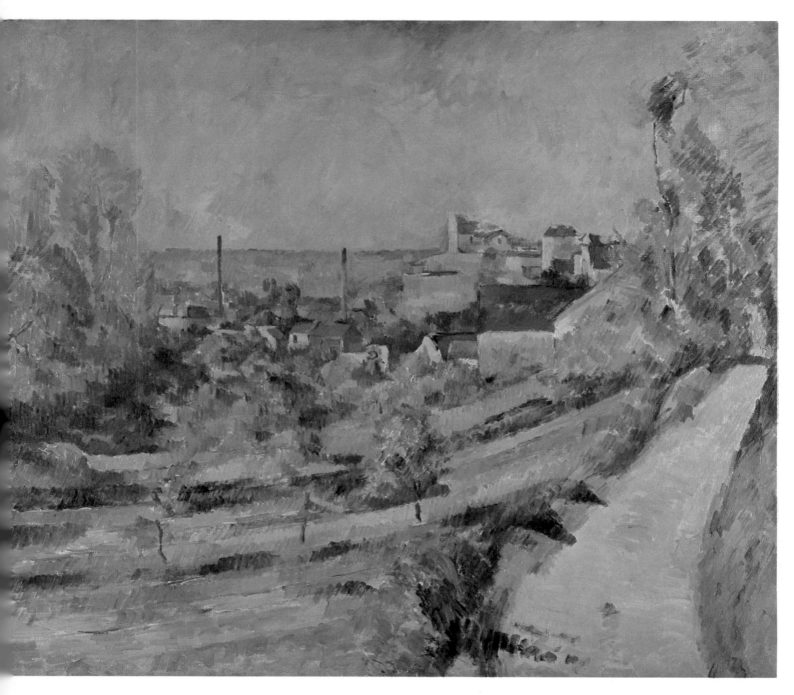

L'Estaque: the Village and the Sea. 1879–83. L'Estaque was a village on the Mediterranean coast, just outside Marseilles, where Cézanne's mother owned a property. Cézanne stayed there in 1870 and on a number of subsequent occasions, and the hard light and strong colours helped to emancipate him from the Impressionist preoccupation with subtle atmospheric effects. Rosengart Collection.

whereas men with families to support, such as Monet, Pissarro and Sisley, were sometimes close to desperation. The economic boom had collapsed even before the first Impressionist show opened; Durand-Ruel got into dire financial straits and was forced to stop buying; and when, in March 1875, Renoir organized an auction of paintings by himself, Monet, Sisley and Berthe Morisot at the Hôtel Drouot in Paris, the event was little short of a riot and the bids ludicrously, humiliatingly low – a clear indication of the harm that the Impressionist exhibition had done to the exhibitors' reputations.

One supporter who turned up at the Hôtel Drouot sale was Victor Chocquet, a customs official whose excellent taste made it possible for him to build up an impressive collection with relatively limited means. Having acquired a number of paintings by Delacroix, the great master of colour in an earlier generation, he now became an admirer of the Impressionists. Renoir was particularly friendly with him, and one day took him to Tanguy's and showed him some works by Cézanne. Chocquet bought a *Bathers*, had himself introduced to Cézanne, and became the painter's friend and most enthusiastic patron. He appreciated and purchased other painters' works (notably those of Renoir and Monet), but his collection of Cézannes was unsurpassed, reaching the astonishing total of thirty-two by the time of his death. He was the first person – and for years to come the only person – to believe that Cézanne was a genius *and* that he might be greater than his contemporaries. For a self-doubting artist such as Cézanne, the very existence of such a man must have provided valuable reassurance.

47

Unlike Gachet and Tanguy, Chocquet did sit on several occasions for Cézanne, who in 1875–76 painted a striking, rugged head of his friend; this was followed soon afterwards by a seated portrait notable for daring formal and colouristic devices which suggested that he was already moving beyond Impressionism.

Chocquet became a familiar figure at the Impressionist exhibitions, often in attendance and always ready to explain and defend Cézanne and the others to sceptical members of the public. By contrast, Cézanne's enthusiasm for Impressionism as a cause waned rapidly. He had not offered any canvases at the Hôtel Drouot sale, and did not exhibit at (or even attend) the second Impressionist show in 1876, although he submitted work to the Salon – unsuccessfully, as ever. His letters to Pissarro from Aix and L'Estaque indicate that he was irritated by the rivalries that developed between the anti-academic painters (for a time there were two hostile 'cooperatives'), but all the same he sent sixteen paintings to the third group show in 1877, which for the first time shamelessly advertised itself as 'The Exhibition of Impressionists'. Concurrently, a young critic, Georges Rivière, published a pamphlet, *The Impressionist*, in which the new tendency in painting was analyzed; among other observations, Rivière described Cézanne as a great artist who was, however, doomed to remain unfashionable. But the actual exhibition pleased critics and public no more than it had done in the past,

L'Estaque. 1882–3. Painted at about the time Auguste Renoir paid Cézanne a visit at L'Estaque. Musée du Louvre, Paris.

and over the next few years there were some despairing defectors – notably Renoir and Monet – who again began submitting work to the Salon.

Cézanne himself never again exhibited with the Impressionists, although there were five more shows between 1879 and 1886. This could be seen as part of his gradual withdrawal from the Parisian world if he had not continued to submit to the Salon, at which Renoir and Monet had begun to enjoy a success that Cézanne was never to know. The simplest – possibly the correct – explanation is that submission to the Salon was a gesture easily made (which is not to say there was no pain in rejection), whereas participation in the Impressionist shows entailed intrigue, organization and personal contact – all the human involvement that Cézanne increasingly shunned. As the 1870s moved to a close, he appeared less and less often among his old acquaintances in Paris, and was hardly ever seen at the Nouvelle-Athènes, a café just off the Place Pigalle that had replaced the Guerbois as a rendezvous for Manet, Degas and their literary friends. When he did come, Cézanne was as provocative as ever, appearing in a battered old hat and a paint-splashed linen coat, like a man determined to remind others of his existence at the smallest possible cost in time and trouble.

He did, however, keep in touch with more intimate friends such as Zola and Pissarro. Zola, now a prolific and successful novelist, showed himself willing

to help his old school-fellow in the domestic crisis that beset Cézanne in 1878. Having decided to spend some time in the South, Cézanne installed Hortense and Paul in an apartment at Marseilles where he could visit them regularly from Aix. Louis-Auguste Cézanne's suspicions may have been aroused by his son's comings and goings, and they appeared to have been confirmed when he opened a letter to Cézanne from Victor Chocquet, who sent his best wishes to 'Madame Cézanne and little Paul'. The row that ensued was serious enough for Cézanne to write telling Zola that he might be compelled to find a means of supporting himself; he even asked Zola if he could use his influence to find his old friend a job. Meanwhile he defended himself against his father (who wished to rid Cézanne of what he conceived to be an unfortunate connection) by obstinately refusing to admit the existence of either 'Madame Cézanne' or 'little Paul'; whereupon Louis-Auguste cut his son's allowance to a meagre 100 francs a month, arguing that it was quite sufficient to support a man without dependants. To make matters worse, little Paul was ill. On one occasion Cézanne went to see him, missed his return train, and was so alarmed by the possible consequences that he walked the thirty kilometres from Marsailles to Aix in order to put in an appearance (albeit an hour late) for dinner at the Jas de Bouffan. During this time he was saved by Zola, who regularly sent Hortense money until the crisis finally passed about a year later. As an instance of tyranny and spiritless dependence it was all the more pathetic in that Cézanne was thirty-nine years old; its ironic aspect was that Cézanne was already quite a wealthy man on paper, since Louis-Auguste had put much of his fortune in his son's name to avoid tax, although he evidently managed to keep control of it in his own hands.

In the spring of 1879 Cézanne was able to leave Aix, presumably with relief after the crisis at the Jas de Bouffan; he spent most of his time for the next two and a half years working in the environs of Paris (at Melun, Pontoise, Fontainebleau), with briefer stays in the capital or in his southern refuge at L'Estaque. He continued to see a few old friends: he stayed with Zola at the novelist's grand new house at Médan, and spent the summers of 1879 and 1881 working with Pissarro at Pontoise. The following year (1882), Renoir, on his way back from Italy, called in on Cézanne at L'Estaque and was so captivated by the scenery that he stayed a month; while working outdoors with Cézanne he contracted pneumonia and was devotedly nursed back to health by Cézanne and his mother, whose cooking remained one of Renoir's treasured memories. Renoir noticed Cézanne's impetuosity, and in particular the way in which he would simply abandon an unsatisfactory canvas among the rocks where they had been working. At Médan too he could be temperamental: while he was painting Zola's wife Gabrielle, an unfortunate remark by their mutual friend

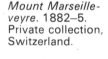

Mount Marseille-veyre. 1882–5. Private collection, Switzerland.

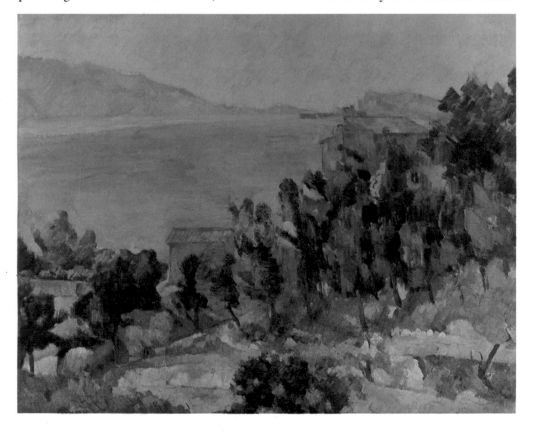

Guillemet was sufficient to make Cézanne slash the canvas, break his brushes and stalk away in a rage. Zola forgave his friend such outbursts, but they must have reinforced his conviction that Cézanne had failed to master his temperament and was still struggling and experimenting rather than achieving. This view, which Zola expressed in one of a series of articles on Impressionism that he wrote in June 1880, was only an echo of what Cézanne himself had told him ('I am still struggling to find my way as a painter. Nature presents me with the greatest difficulties.'), but in such matters a man hardly expects to be taken quite literally, and Zola's judgement must have pained and troubled Cézanne.

In reality, Cézanne was struggling, experimenting *and* achieving at one and the same time. Despite his summers with Pissarro, he had gone well beyond Impressionism by 1881, seeking to create 'something solid and durable' rather than the fugitive effects captured by the Impressionists. Even one of his early, 'Impressionist' paintings such as *The House of the Hanged Man* has a monumentality – a feeling for the presence of mass and volume – that resists the dissolvent quality of light so apparent in contemporary Impressionist paintings. Part of Pissarro's attraction for Cézanne as a teacher may have been the former's relatively strong feeling for structure (strong for an Impressionist, that is); but, as two often compared pictures demonstrate, there remained a wide difference between the ways in which the two men approached the same subject. Pissarro's painting of the orchard behind his house at Pontoise (1877) is an atmospheric, leafy evocation of blossom-time, whereas Cézanne's version, done in the same year, is more stable and austere; his trees are barer, his colour-scheme simpler and bolder, and – an earnest of things to come – he has not hesitated to reorganize nature, putting in fewer trees and enlarging the houses on the slope behind the orchard so that their solid forms and emphatic outlines give weight to the composition. Even when most under the spell of Impressionist broken brush-

Rocks at L'Estaque. 1882–5. A painting of rocks strong as eternity, from the period in which every element in Cézanne's work – water as well as rock – was rendered with unparalleled strength. Museo de Arte de São Paulo.

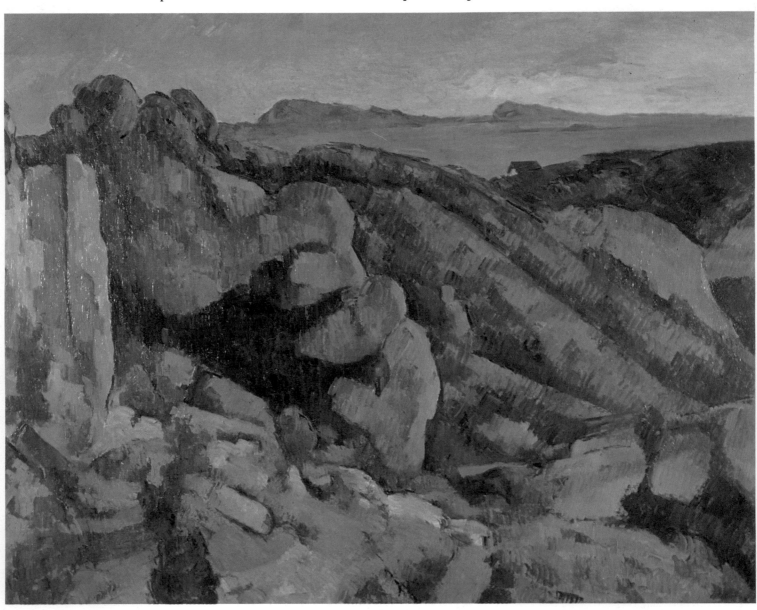

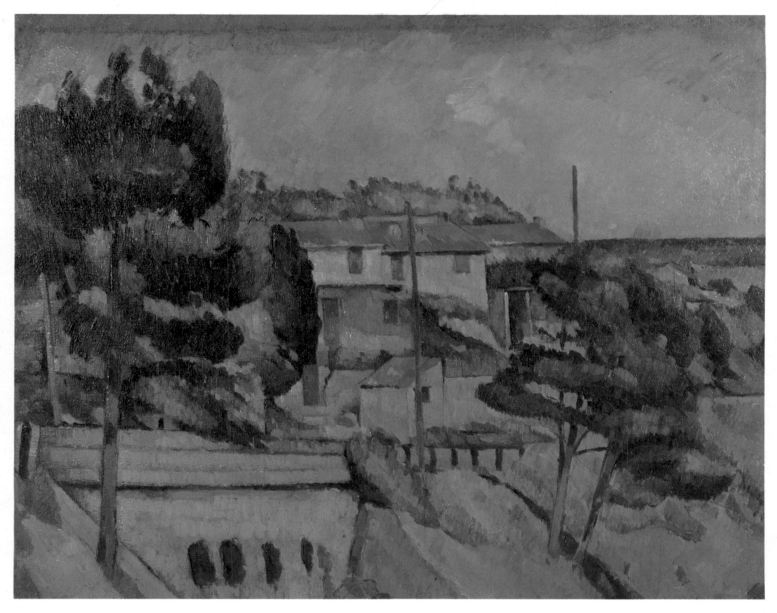

The Viaduct at
L'Estaque. 1882–5.
Art Museum of the
Ateneum, Helsinki.

work and brilliance of colour (two of his permanent debts to the movement) Cézanne was not primarily interested in the play of light which broke up surfaces into multicoloured areas of sheen and shadow; in a painting such as the panorama of Auvers (1873–75; Art Institute of Chicago), for example, he insists upon the strong local colour (that is, the colour unmodified by atmosphere or environment) of the red village roofs.

Working in his native Midi confirmed these predilections of Cézanne's. From L'Estaque he wrote to Pissarro (2 July 1876) comparing the scenery – red roofs juxtaposed against blue sea – to a playing-card design. What he meant was that the Southern sun created a landscape of strong colours and harshly outlined forms; the sea appeared calm and hard, and flat and brilliant in colour; even the vegetation was more intense and more durable than in the North, giving a slow worker like Cézanne the time he needed to realize his conceptions. By contrast, the characteristic Impressionist land- or seascape is essentially Northern – changeable in itself and liable to endless modifications in appearance according to the quality of the light and other atmospheric factors. It has been suggested that Cézanne developed away from Impressionism because his world – the South – was a different one from that of Monet and the others. But such an explanation is over-simple. The Southern landscape may have deeply influenced Cézanne's sensibility, but it answered rather than created his craving for order and permanence; after all, he was not an exclusively Southern artist, but over the years spent long periods working in the Ile de France area, which he approached with the same craving and stripped down in essentially the same fashion.

Cézanne's laboriously achieved order can be more satisfactorily interpreted as the obverse of – and antidote to – his unbridled romanticism and the reckless violence and sensuality lurking within it; psychologically and aesthetically,

Houses at the
Viaduct at L'Estaque.
c. 1876. Art
Institute of Chicago.

Terraced Hills with
Houses and Trees.
c. 1880–3. Pencil
drawing.
Kupferstichkabinett,
Basel.

stability and control were both the condition and the goal of Cézanne's endeavours – in his case, capable of achievment only by suppressing almost every hint of emotion and relegating human beings to formal elements in his paintings, no more or less important than other objects. Could it be more than a coincidence that Cézanne's great boyhood friend, Emile Zola, subjected himself to a not dissimilar discipline? Having written some distinctly morbid and melodramatic novels in which lust and murder go hand in hand, Zola devised the pseudo-scientific literary doctrine of Naturalism (a variation on Realism) and set himself to create a huge 'objective' panorama of French society in the twenty novels of the Rougon-Macquart cycle. Though sensational in contemporary terms, these do represent an attempt at salvation through control – a distancing by means of reportage – as is apparent when the control breaks down, for example in fantastic wish-fulfilment descriptions of hothouse sexuality (*The Kill*) and a wild sequence of fatalities involving adultery, uncontrollable bloodlust, a train derailment and suicide (*The Beast in Man*). Here we are evidently not far from the ethos of Cézanne's early painting, and it becomes tempting (if ultimately futile) to speculate about the shared mental world of Cézanne and Zola in those boyhood days to which both looked back with intense nostalgia.

When Cézanne joined Pissarro at Pontoise in the summer of 1881, his old friend had acquired yet another disciple – Paul Gauguin, not at this time the legendary Tahitian 'primitive' but a successful broker's agent who was only able to paint in his spare time and on holiday. Gauguin greatly admired Cézanne's work, and learned from it; but Cézanne did not care for Gauguin. Later, in a letter to Pissarro, Gauguin made the rather feebly humorous suggestion that Cézanne should be drugged so that he would reveal his special 'formula', which was enough to set Cézanne off on a fit of suspicious panic and rage. The incident reveals the intensity of his paranoia, but it also indicates his conviction that he *did* possess a 'formula' – that he had become an artist well worth stealing from.

Turning Points

In the spring of 1882 Cézanne at last achieved recognition of a sort when one of his paintings was shown at the annual Salon. However, the work (a portrait which has failed to survive) was not accepted on its own merits. Antoine Guillemet, a painter-friend who had made a conventionally successful career, exercised his privilege as a jury member to have one work by a pupil accepted without debate; and so Cézanne's name finally appeared on the dubious Salon roll of honour, among hundreds of others, in the humiliating fictional guise of 'pupil of Guillemet'. The chosen painting attracted no particular attention, but if Cézanne was disappointed or disgusted, he showed no sign of it. For the next four years he continued to submit works to the Salon juries, which turned them down as regularly as before.

Cézanne left Paris in October 1882 to winter in Provence, as he had often done before. In the event, he remained in the South for two and a half years, at first tramping the countryside and working in the company of Adolphe Monticelli (a fifty-eight-year-old Marseilles painter now remembered mainly for his flower-pieces), and later settling with Hortense and his son Paul at L'Estaque, where his only contact with the wider world consisted of a brief visit by Monet and Renoir on their way back from an Italian trip. During this period of intense communion with the Southern landscape, Cézanne's distinctive personal style revealed itself in its full force. Neither in earlier nor in subsequent phases of Cézanne's art is the rigorous organization of the picture surface displayed so openly. *The Bridge at Maincy* (1882–85), for example, is a marmoreal work in which even the reflections in the river are as hard as the bridge itself; here and elsewhere, Cézanne's brush-strokes are marshalled to form a close, emphatic pattern that plays an important role in the spectator's visual experience, knitting together all the parts of the surface into a unified whole.

This unity is of a special kind, created by an organization of parts, each of which has a richness and strength of its own. The rarity of neutral or 'dead' areas – the visual relevance of every section of the surface – is perhaps the

The Bridge at Maincy. 1882–5. Another marvellously solid painting from this period. The reflections in the water are as substantial as the pictured 'reality'. Musée du Louvre, Paris.

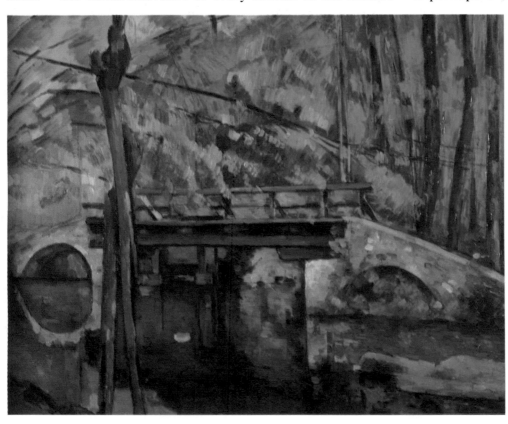

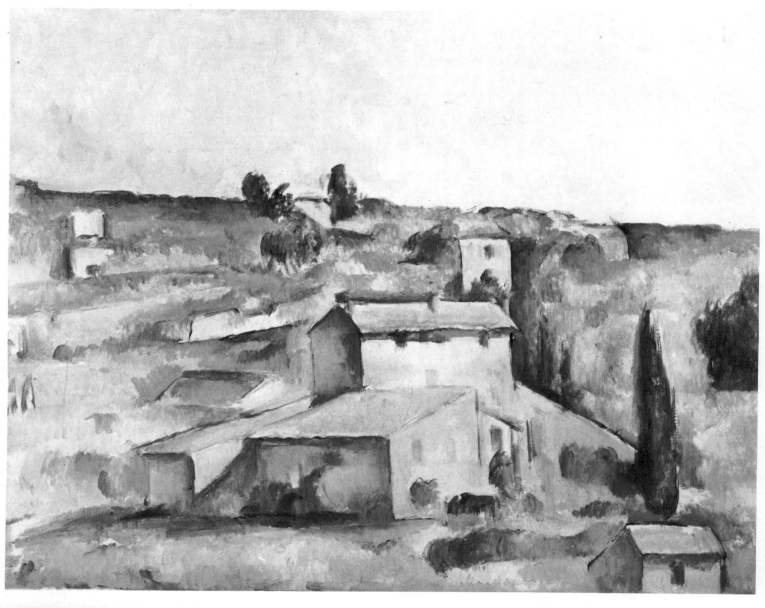

Adolphe Monticelli. *Wild Flowers*.
Monticelli (1824–86) was an artist from
Marseilles, now chiefly remembered for
his flower paintings. He and Cézanne
worked side by side in the Aix-Marseilles
area in 1883. National Gallery, London.

strongest single impression made on the mind by an exposure to Cézanne's mature art. Once this is seen as his aim, many other aspects of his work become easier to understand. Only painful, persistent labour could be expected to produce canvases in which every smallest area was intended to 'work' and at the same time to relate harmoniously to every other area. And only one painting method could bring it about – a near-simultaneous attack, undertaken with a constant awareness of the shifting formal and colouristic relationships over the entire surface; 'I advance all my canvas at one time together,' Cézanne explained in his characteristically oblique style. It was also inevitable that the sky – a relatively 'neutral', featureless area – should play a subordinate role in most of Cézanne's landscapes; on occasion he even eliminated it altogether. Water, as we have seen, became a brilliant but solid element, with none of the ripple- and light-dissolved quality found in Monet's art. The sense of atmosphere and movement, of flowing water and breeze-blown leaf, is one of the charms of Impressionist painting, but it was a charm that Cézanne felt compelled to renounce in order to realize his personal vision of stability and permanence. He also sacrificed other Impressionist and conventional effects of light and shadow, avoiding strong contrasts that would disrupt the continuous, integrated picture surface he wished to create; in fact shadows play a remarkably small part in Cézanne's paintings, and seem to have been included – sometimes inconsistently – in the interests of formal rather than realistic effects. Cézanne's light is necessarily even and 'invisible', not a shadow- and contrast-making emanation from a single source. In this and in other respects he placed artistic effect above literal realism.

This is even more strikingly apparent in the way he abandoned the conventional system of representing spatial relationships in a picture. For several hundred years, since the Italian Renaissance, European painters had chiefly

Left: *Fields at Bellevue*. 1885–7. Phillips Collection, Washington, D.C.

Medea (after Delacroix). 1879–82. For all his originality, Cézanne, like other great artists, learned much by copying, which remained a lifelong practice. He greatly admired Delacroix, Rubens, the Venetians and other colourists, as well as more 'classical' painters such as Poussin. Kunsthaus, Zurich.

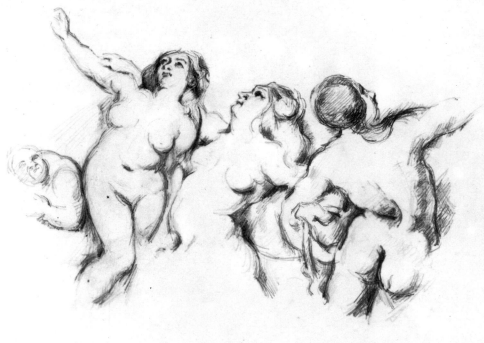

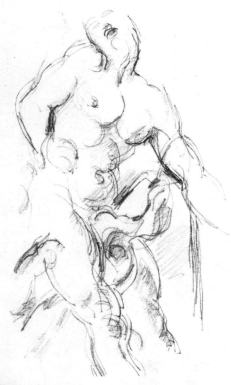

Above: Sketch of a Cupid. *c.* 1890.
Cézanne owned a cast of the statuette he
has drawn here; the original was
attributed to Puget. It also appears in
two rather uncharacteristic still-life
paintings. British Museum, London.

Above right: *Three Naiads*. 1876–9. Pencil
drawing after Rubens' painting *Marie de
Médici's Landing at Marseilles*. Collection
of Marianne Feilchenfeldt, Zurich.

Above: *Milo of Crotona*. *c.* 1880–3.
Drawing after a well-known statue by the
17th-century sculptor Puget. In classical
myth, Milo was an athlete who became
trapped in the cleft of a tree and was torn
apart by wolves. Kunstmuseum, Basel.

Far right: *Dahlias in a Delft Vase*. 1873–5.
Musée du Louvre, Paris.

relied for this on the study of perspective, which analyzed and described in strict
mathematical form certain aspects of human vision: that the further away an
object is the smaller and less distinct it looks; that parallel lines appear to converge
at the horizon; that colour tones seem to fade with distance; and so on. From
Cézanne's point of view, such techniques had an important drawback: they faded
or 'devalued' some parts of a painting, whereas he wanted to give almost every
part a certain force – for example, to give an arm of land, seen across the Bay of
Marseilles, the same strongly coloured 'presence' as the foreground landscape.
For such purposes he elaborated his own means of conveying depth without
employing perspective; the most notable were overlapping (if object A is painted
so that it overlaps object B, the eye will 'read' A as being nearer) and a careful
exploitation of the fact that an object painted in a warm colour such as red
seems closer than one painted in a cool blue or green.

These and other devices give the spectator an adequate notion of depth – but it
is a notion, virtually a species of information, rather than the traditional eye-
deceiving illusion intended to deny the two-dimensionality of painting. When
looking at Cézanne's paintings we are simultaneously aware of them as repre-
senting depth and presenting a flat, patterned surface that has been organized
and coloured to express a sensibility – a specifically modern experience, at least
for the Western spectator. Implicit here is the conception of a work of art as an
autonomous object that is independent of reality – and possibly, as in abstract
art, unrelated to anything in the natural world. For many 20th-century artists
Cézanne was therefore a great liberating force who revealed a world of intoxi-
cating new possibilities. However, he himself never envisaged a break with
representational art: for him, contact with nature was central to the artist's
activity, a necessary source of aesthetic emotion, however much it might need
to be rearranged on the canvas for the sake of perfect expression. In fact
Cézanne seems to have felt that in some obscure sense he was discarding literal
accuracy in order to grasp and express fundamental truths about nature rather
than to assert the primacy of art.

He certainly regarded himself as a renovator, not a revolutionary; towards the
end of his life he told a young admirer, 'One does not substitute oneself for the
past, one only adds a new link.' In broad historical terms his work can actually
be seen as an attempt at reconciliation in a war between two main schools –
between those who believed that colour was the soul of painting and those who
held that sound drawing was its basis. In slightly different forms, this conflict
had broken out several times over the centuries, between the followers of Rubens
and the followers of Poussin, between Ingres and Delacroix. It is significant
that Cézanne should have been able to admire the great classic constructions of
Poussin and yet to have been equally passionate in his devotion to Rubens and
Delacroix. He was himself a colourist of brilliance, but his solid modelling and

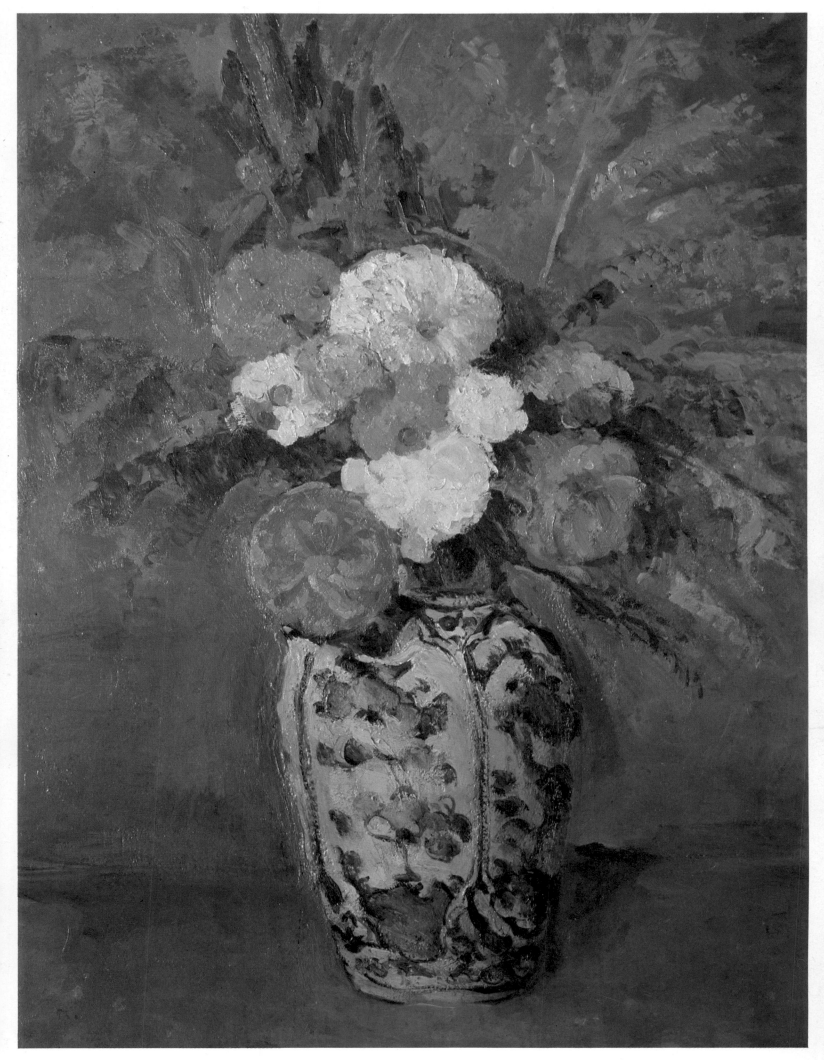

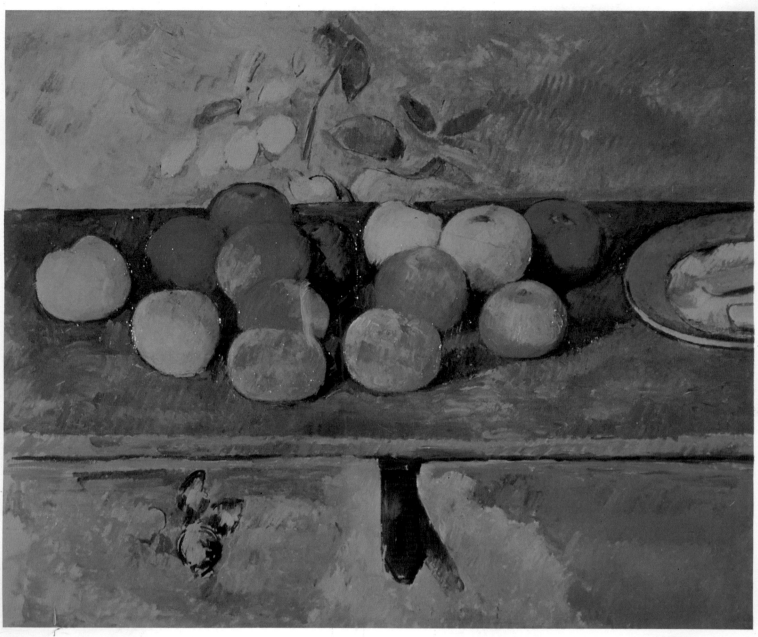

Above: *Still Life
with Apples and
Biscuits. c.* 1881.
Cézanne's treatment
of still life made it —
arguably — the
ideal genre for the
modern painter: an
arranged reality that
could be further
manipulated in the
process of painting.
Musée du Louvre,
Paris. (Collection
Walter Guillaume.)

Left: *Still Life with
a Soup Tureen*.
1883–5? An
unusually warm
still life, of uncertain
date. The painting
in the background
is by Cézanne's
friend and mentor
Camille Pissarro.
Musée du Louvre,
Paris.

Still Life with Fruit Basket. c. 1888–90. A superb, dense composition in which Cézanne has taken many liberties with visual reality; notice the discontinuous line of the table edge. Musée du Louvre, Paris.

immense constructive labours made him just as fully a member of the alternative tradition. The fusion he accomplished was a premeditated one, as his recorded statements proved: he wanted to make something solid and durable of Impressionism – and also 'to re-do Poussin after nature', or in other words to renew the classic tradition by bringing it into contact with the fresh, colourful qualities that could only be achieved by working directly from nature.

Cézanne was even more emphatically a renovator in another branch of painting, the still life, which had been largely neglected by 19th-century artists. Manet was an honourable exception to this tendency, but it was Cézanne who actually revived the genre, painting some 200 examples that would directly influence the following generation of painters. But, as with landscape painting, the renovation was accomplished by means of a radical change of technique and intention. Earlier artists, and above all the great 18th-century painter Chardin, had brought the realistic and evocative potential of the still life to near-perfection, capturing the tactile qualities of fish scales, clay pipes and rough pottery, and by this means expressing the quiet homeliness of middle-class lives. By contrast, Cézanne abandoned this kind of virtuoso illusionism and set out to create rich, solidly constructed works on similar lines to his landscapes. As if to emphasize his disdain for an appeal to our ordinary senses, he normally used the simplest, least evocative of objects – apples, pears, and undistinguished plates, bowls and bottles. But again it would be wrong to regard Cézanne as a virtual abstractionist, since his fruits are not mere shapes, but invariably have a rounded succulence that influences our response to the work of art; the transaction between artist and reality, however attenuated, remains a significant element in everything by Cézanne.

However, one of the advantages of still life for him was that 'reality' could be arranged to his satisfaction before he began painting; we know that he not only set out the constituents of a still life in front of him, but unobtrusively propped them up so that, for example, the fruit in a dish seemed tilted forward by some invisible force; when painted, the result was optically impossible but brought forward the bowl and fruit strongly into the picture-surface pattern. Other distortions of literal reality included the showing of an object from two incompatible points of view (a device later taken to its limit by the Cubists) and, in a painting such as *Still Life with Fruit Basket* (*c.* 1888–90; Musée du Louvre, Paris), breaking the line of a table edge by draping a cloth across it, then bringing the edge out from under the cloth – but out of line with the earlier section of the edge. Again pictorial necessity has outweighed all other considerations; such a device, which seemed to many contemporaries no more than a childish error, was indispensable to the whole balance of the painting. (Anyone who doubts this can verify it by making a 'correct' copy of an original, which can be guaranteed to look lop-sided.) Cézanne thus followed his convictions right through, and in doing so showed a quite extraordinary courage in the face of orthodox theory, and even of what passed for simple common sense about art. In the event, his still lifes, marvellously rich and colourful and tightly patterned, rank as some of his supreme achievements.

Cézanne's involvement with still life is easy enough to understand: it was in many respects the ideal genre for a man of his peculiar disposition – the perfectionist, the slow worker with a quick temper. Apple, bowl and cloth had the advantage of being utterly subject to the artist's will, and, unlike the world outside the studio, unaffected by changes in the weather. In contrast to still lifes and even landscapes, human beings were thoroughly unsatisfactory as

Still Life with Apples. c. 1890–4. Here, for greater effect, Cézanne has tilted the composition towards the spectator. Private collection.

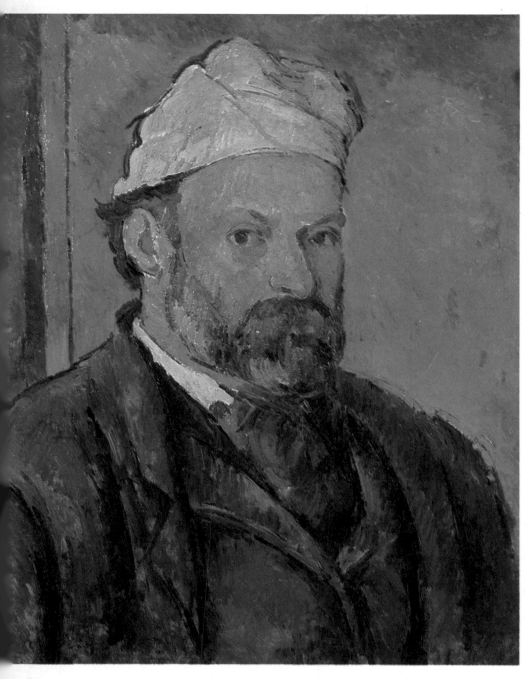

Left: *Self-portrait. c.* 1877–9. Neue Pinakothek, Munich.

Self-portrait, from a sketchbook. 1886. Art Institute of Chicago. (Arthur Hein Fund.)

subjects, since they could not be relied on to remain still for hours at a time; small wonder that Cézanne was liable to reprove the fatigued sitter by enquiring sarcastically, 'Do apples move?' A further difficulty lay in Cézanne's extreme social unease, which meant that prolonged contact with another human being built up powerful tensions that were likely to explode at the slightest imagined provocation, as was the case when he undertook Madame Zola's portrait.

For much of the 1870s and '80s he was able to get round these difficulties by painting the only two sitters who were both docile and comfortingly familiar: himself and Hortense. The fifty-odd self-portraits and portraits of Hortense that he painted during his lifetime manifest the most striking aspect of his work as a portraitist: his utter lack of interest in psychology, or even (with a few exceptions) in the distinctive human quality of the subject. In the self-portraits there is perhaps a certain severe presence (1880–81; Musée du Louvre, Paris) and sometimes a look of challenge, as if expressing resentment at the spectator's intrusion (1879–82, Kunstmuseum, Bern, and 1883–87, Ny Carlsberg Glyptotek, Copenhagen); otherwise Cézanne's portraits are remarkably uninformative *as* portraits, however fine they may be as works of art; they are apparently the works of a man for whom people are objects – *motifs* – on a par with apples and oranges. There are variations in technique and intention from one portrait to the next, but they mainly relate to Cézanne's artistic pre-occupations rather than to variations in his feelings about (or observation of) his subject. This must represent Cézanne's mature conviction as to what a painting should be concerned with, since his youthful portraits – of the vulnerable

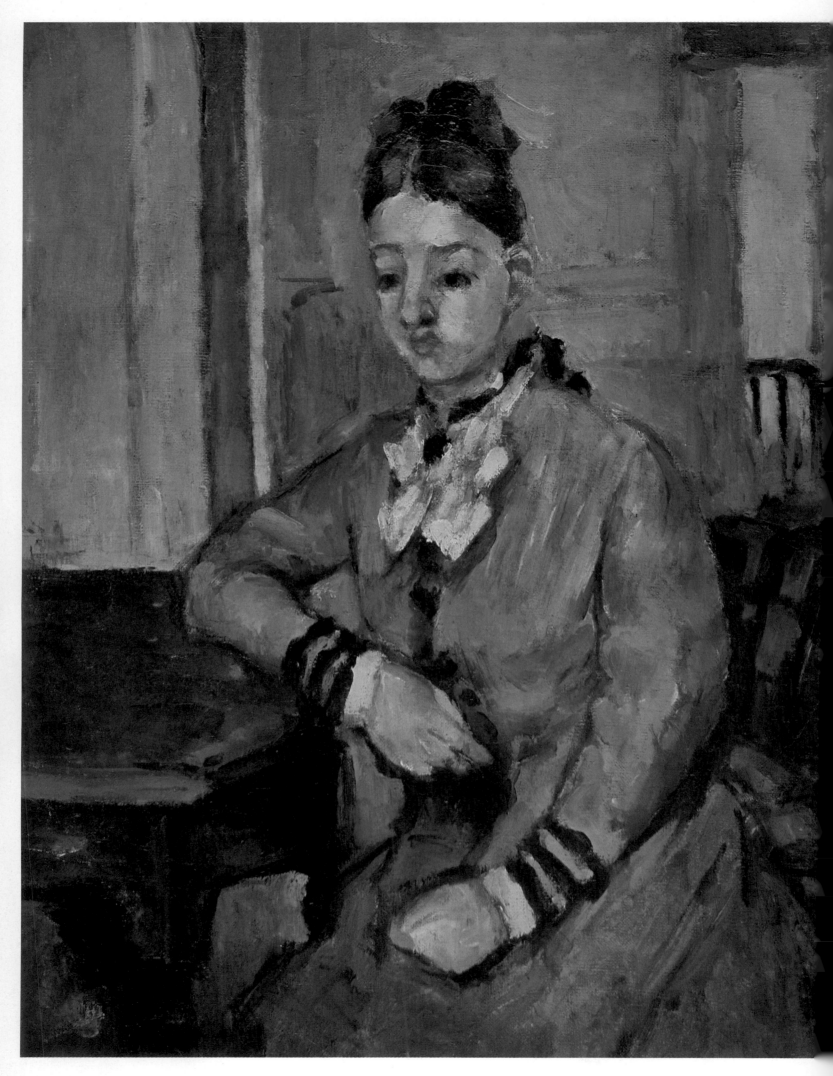

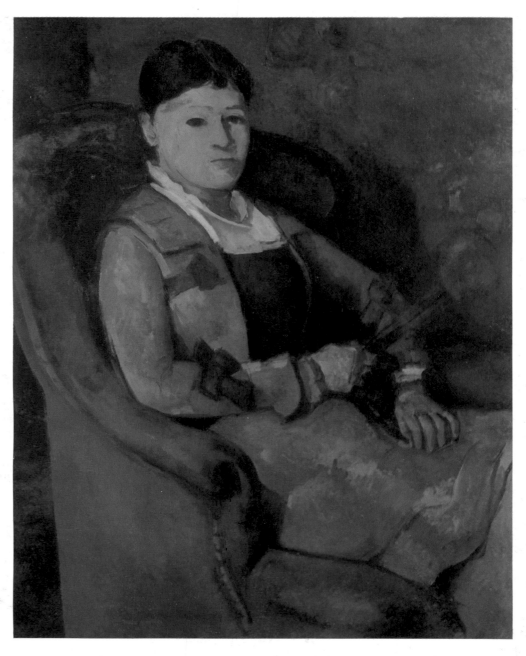

Left: *Madame Cézanne Leaning on a Table*. 1873–7. Private collection, Geneva.

The Lady with the Fan. 1879–82. Private collection, Zurich.

Empéraire, of the head of an old man (1865–68; Musée du Louvre, Paris), and others – are characterized by a definite emotional response. By contrast, the portrait of Hortense, the future Madame Cézanne, as *The Lady with the Fan* (1879–82; Bührle Collection, Zürich) is superb as an organization of mass and colour, but the woman herself, with her large, under-articulated face, might be anyone – any woman with a severe hairstyle and a heavy jaw. We learn nothing more than that about her from superb decorative paintings such as *Madame Cézanne in a Red Armchair* (1877) and *Madame Cézanne in the Conservatory* (*c.* 1890), or from more austere work such as the São Paulo *Madame Cézanne in Red* (*c.* 1890).

All this is to say that Cézanne treated the portrait much as we have already seen him treating the landscape painting and still life, with only a limited concern for literal accuracy or for any emotion from a source outside the painting itself. Having abandoned the strange and feverish style of his youth, Cézanne perhaps felt a particular need to treat the human element in his work with caution. All the same, the impulses that had given rise to paintings of rapes and orgies were still given expression from time to time, although in increasingly refined form and lighter mood, modulating through 'bacchanals' in which naked couples engaged in an open-air 'struggle of love' ('La Lutte d'Amour' is an alternative title for the 'bacchanals') to studies of bathers that were to become one of Cézanne's abiding obsessions. In spite of everything – even in spite of his inhibitions about employing nude models, which he later excused as a necessary concession to public opinion – Cézanne's traditionalism was so ingrained that he continued to regard figure-painting as 'the culmination of art'. His later efforts in this direction are, for many people, his supreme achievements.

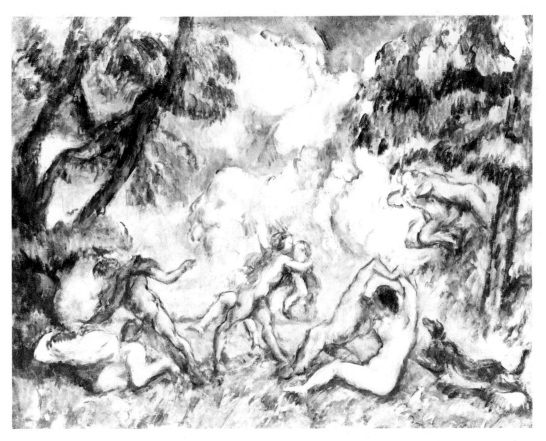

The Battle of Love.
1875–80. Cézanne's
paintings on this
theme, also known
as 'Bacchanals',
represent an
intermediate stage
in the transformation
of his early violent
nudes into the
'Bathers' of his last
years. National
Gallery of Art,
Washington, D.C.
(Gift of the W.
Averell Harriman
Foundation, in
memory of Marie
N. Harriman.)

In Cézanne's private life, the years 1885–86 constituted a turning point. Early in 1885 he seems to have had a love affair, possibly with a servant at the Jas de Bouffan; the details are utterly obscure, since the only documentary evidence consists of a fragmentary draft of a love letter on the back of a drawing, and a note to Zola requesting in the most urgent terms that the novelist should allow his address to be used as a poste restante for Cézanne, who evidently contemplated engaging in a surreptitious correspondence. But by mid-June 1885, less than a month later, Cézanne was in the North, at La Roche-Guyon, a little spot on the Seine, staying with Renoir; we must assume that the affair was over – if indeed it ever really got started. After staying with Zola at Médan, Cézanne returned to the Jas de Bouffan, from which he wrote to Zola on 25 August 1885, complaining obscurely of his 'complete isolation' which, it appeared, was broken only by visits to the town brothel.

If, as this cryptic information seems to imply, there had been some breach between Cézanne and Hortense, it was more than healed by the following year. In August 1886 Cézanne was finally allowed to marry her, thus legitimizing his fourteen-year-old son. The paterfamilias, Louis-Auguste, probably yielded to pressure from Cézanne's mother and sister Marie; he was almost eighty-eight and perhaps already in his last illness. In October of the same year he died, and Cézanne became for the first time an independent man of means. 'My father was a genius,' he once remarked in his sardonic fashion. 'He left me an income of 25,000 francs.' In the event, neither marriage nor money made a great deal of difference to Cézanne's way of life. Hortense remained uncomfortable at the Jas de Bouffan, and preferred to spend long periods with her son in Paris. The arrangement appears to have suited Cézanne, who was becoming more rather than less unsociable. The practical side of his life was run by his sister Marie, while he continued to go out on fine days with his familiar pack on his back, painting at favoured spots – latterly the little hill village of Gardanne, which inspired some of his most rigorously geometricized landscapes.

Cézanne's isolation was intensified by his sudden break with Zola. On the surface, this thirty-year-old relationship had been as close as ever in 1885, when Cézanne had appealed to Zola for help in his love affair, addressing his friend in the warmest terms. But there had probably been strains for some years between them. Zola was the poor boy who had made good, Cézanne the rich boy who hadn't. Zola revelled in his success, furnished his grand house in ornate bad taste, and enjoyed good living and good company – all of which was despised as thoroughly bourgeois by Cézanne, a bourgeois-turned-bohemian who was a failure in worldly terms; the fact that Zola had proved himself such a generous

friend may have been a source of offence as far as the touchy Cézanne was concerned.

Yet it was Zola who caused the break by his portrayal of Cézanne in a novel, *The Masterpiece* (*L'Oeuvre*). The central character in the book is the painter Claude Lantier, to whom Zola gave the same Southern boyhood as Cézanne, along with a similar group of Provençal friends – including the writer Sandoz, easily identifiable as Zola himself. Worse, Zola revealed areas of Cézanne's personality that the painter had carefully suppressed, ascribing to Lantier the strange mixture of tortured abstinence and erotico-artistic frenzy so apparent in Cézanne's twenties. Worst of all, Lantier is shown as a failure – a genius who has missed his way, as Zola now certainly considered not only Cézanne but all his Impressionist friends; and, as a final insult, the fictional painter is made to end his life in madness and suicide. Zola's motives for this onslaught may have derived from the tensions between the two men, a naïve belief that the fictional elements in Lantier's character sufficiently disguised its source, or a writer's inability to resist using good literary material: we simply do not know. Neither Zola nor Cézanne ever discussed the episode, and there was no open quarrel. In a note from Gardanne dated 4 April 1886, Cézanne thanked Zola for sending him a copy of *The Masterpiece*, asked him 'to allow me to press his hand in memory of old times,' and ended 'Ever yours under the impulse of years gone by' – a touching but unmistakably elegiac note. As far as is known, the two men never communicated again: Zola's public references to Cézanne's work remained friendly if unenthusiastic, and although Cézanne sometimes railed against Zola in conversation, when Zola died in September 1902 he burst into tears and locked himself in his study for the rest of the day.

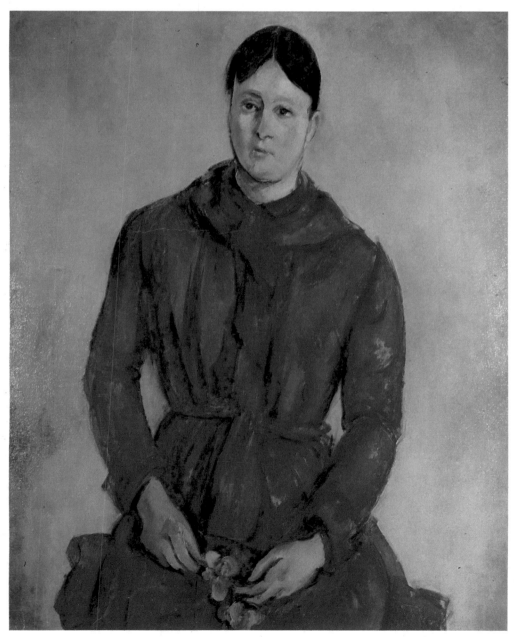

Madame Cézanne in Red. c. 1890. In this and other portraits of Cézanne's wife we notice variations in the painter's technique; we learn nothing of the woman herself. Museo de Arte de São Paulo.

The Master of Aix

After 1886 Cézanne's life was outwardly uneventful. He seemed to have been forgotten by the art world, and ceased even to submit his works to the Salon. Aix became his permanent home, which he left only briefly except under duress: Hortense took him with her to Paris in 1888, and in 1891 even led a five-month-long family trip to Switzerland – Cézanne's only experience of a foreign country. Perhaps in revenge, he allowed his sister Marie to persuade him that Hortense's absences in Paris were a scandal, and in 1892 she was forced to return to Aix. However, as she and young Paul lodged in the town while Cézanne continued to live at the Jas de Bouffan, public appearances cannot have been much improved, and Cézanné was probably glad to resume the old arrangement and be left in peace. There was no separation in the technical sense, and from time to time the family was united; in the winter of 1901/2, for example, Hortense and Paul were at Aix, where a young admirer of Cézanne's, Léo Larguier, observed that the painter had no time for his wife but obviously adored his son. Cézanne said contemptuously of Hortense that she liked only Switzerland and lemonade, and most of his friends seem to have thought her empty-headed; but of course they may have been biased. In any case, Cézanne was probably incapable of living with any woman; for that matter, although he loved his son and in later years entrusted the management of his professional affairs to him, Cézanne was content to do most of his loving at a distance. His private existence remained undisturbed until 1899, when the Jas de Bouffan was sold to settle the estate of his mother, who had died two years before. At this point his sister decided to live separately from him, but when Cézanne returned from a stay in Paris she none the less organized his life at Aix, installing him in a town flat with an attic studio; the only change he made in the arrangement was eventually to buy a piece of land and build on it the more capacious studio he needed.

These uneventful years were enormously productive. From the mid- to late 1880s, his landscapes were constructed with less overt rigour – the paint is often thinner and the close, patterned brush-strokes absent – but the underlying

The Lake at Annecy. 1896. A landscape from a part of France unfamiliar to Cézanne, painted after he had taken a rest cure at Vichy. It is reminiscent in style of his work in the early 1880s. Courtauld Institute Galleries, London.

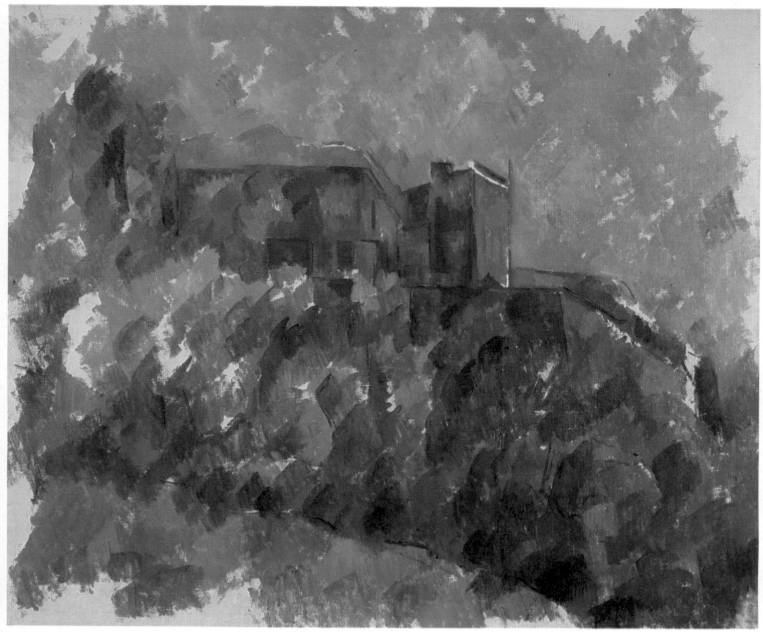

Above: *The Château Noir*. 1904–6. One of Cézanne's favourite subjects painted in his late manner, with roughly rectangular patches of colour built up into a complex pattern. Private collection.

Left: *Rocky Landscape at Aix*. *c.* 1887. National Gallery, London.

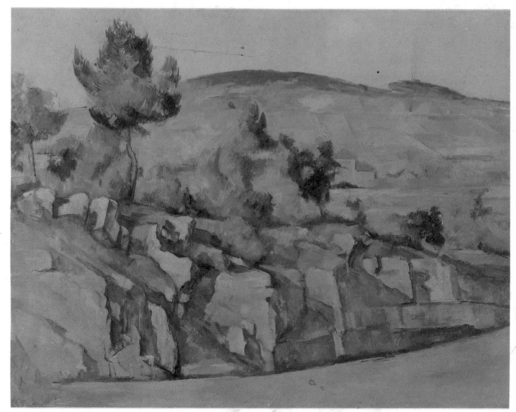

structure was as firm as ever; indeed, around 1885–87 many of his landscapes were virtually geometric in formal arrangement. It was during this period, too, that Cézanne became obsessed with Mont Sainte-Victoire, a nearby mountain that rises abruptly out of the surrounding plain. For Cézanne it appears to have possessed a symbolic or even mystical character, and he painted it some sixty times in the last decades of his life. In this wonderful series we can follow the line of his development over the years, marking the progressive elimination of detail in the paintings and the increasing domination of the countryside by the mountain (albeit at the expense of optical truth), culminating in a near-abstract vision conveyed more and more colourfully and cursorily in the manner of Cézanne's final period.

Even more unexpected was a sudden upsurge of Cézanne's interest in portrait- and figure-painting. In 1888, while spending the year in Paris with his family, he began two curious works, a *Harlequin* for which his son Paul posed in traditional black and red chequered costume, and *Mardi-Gras*, featuring both a Harlequin (Paul) and a white-clad, beruffed Pierrot (young Paul's friend Louis Guillaume). The figures are executed, as we have come to expect, with more respect for formal balance than literal truth; *Harlequin*, for example, has a fascinatingly elongated right leg. But the subject-matter is certainly not as expected, representing an odd, brief caprice on Cézanne's part, while the atmosphere in both paintings is uneasy, perhaps even sinister. From 1890 Cézanne even ventured to use models outside his family circle – though not far outside, since he took the Jas de Bouffan gardener and local labourers as models for the various *Card Players* (1890–92) paintings and related works such as the *Man Smoking a Pipe* (*c*. 1892). The atmosphere in these canvases is again surprisingly strong; in the versions of *The Card Players* featuring only two participants – for example, the one at the Courtauld Institute, London, or the smaller version in the Louvre – they are redolent of heavy labour accomplished, serious attention, decent

Mont Sainte Victoire. c. 1886–8. The most obsessively recurrent of all Cézanne's subjects, painted some sixty times in the last decades of his life. Courtauld Institute Galleries, London.

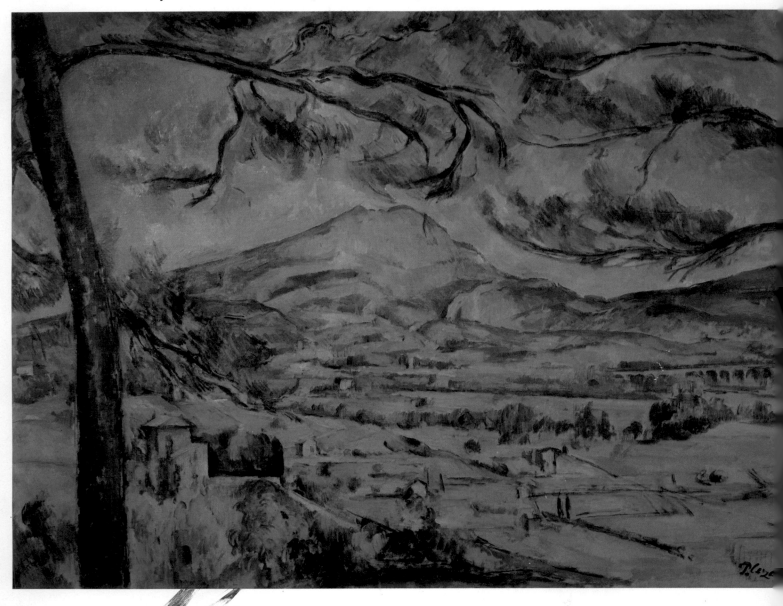

Left: *The Card Players. c.* 1890–2. One of the most successful of this famous series. The tilted horizontals serve to bring the players together, increasing the sense of intimacy, as well as contributing to the great formal complexity of the painting. Musée du Louvre, Paris.

poverty. The formal devices, notably the vertiginous downward tilt of the horizontals, are so audacious – and so effective in enlivening the composition and relating the players to each other – that it is easy to overlook the fact that Cézanne has successfully ventured into the traditional 'tavern scene' genre which, characteristically, he has transposed out of the stereotyped bucolic-jollity mood. In the various versions of the *Boy in a Red Waistcoat* (1890–95), the mood is unusually pensive, with a suggestion of vulnerability that may derive from the model himself – a young professional called Michelangelo di Rosa who must have been unassertive indeed to have pleased Cézanne without causing the artist to suffer a fit of nerves. The most successful versions, those in the Bührle Collection, Zürich, and the Paul Mellon Collection, Washington, D.C., are among Cézanne's loveliest paintings, utterly satisfying in form, harmony and feeling. The Bührle Collection painting is a particularly complex design, in which the boy's famous elongated right arm plays a crucial part.

During this great creative phase, Cézanne lived in such quiet obscurity that most of his masterpieces can only be dated to a period of four or five years. He made no attempt to exhibit, sent nothing to the Salon, and drew into an ever-narrower circle of intimates that hardly extended beyond his family and servants. Most of his early friends from Aix became suspect in his eyes, mainly perhaps because they had also been friends of Zola. The amiable Renoir visited him in 1889, but Cézanne seems to have taken offence at some imagined slight, and relations between the two were suspended. Then, in 1894, it was Monet's turn. In Monet's house at Giverny, a village on the Seine, Cézanne behaved with familiar strangeness – fell on his knees before the sculptor Auguste Rodin, apparently overwhelmed at having his hand shaken by a man who had been decorated with the Légion d'Honneur; then, the following day, he responded to a little party in his honour by bursting into tears, accusing Monet of making fun of him, and quitting the village in a rage. However, there was no decisive quarrel with these or other old friends such as Pissarro – that was evidently not Cézanne's way – but if he saw one of them coming on a Paris street, Cézanne would gesture to him to cross the road and pass on. For their part, Monet and the rest pitied Cézanne for his unfortunate temperament and, hearing reports from the South of his tempers and breakings of friendships, concluded that he was a mentally sick man. In a sense, this was true: he was hypersensitive and morbidly suspicious, half-believing that his contemporaries might – like the detested Gauguin – try to steal his 'formula'. But he also felt a straightforward rivalry

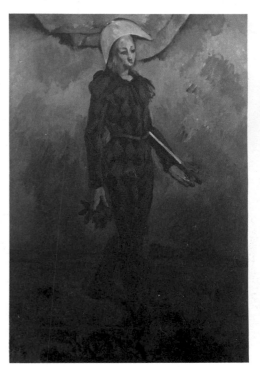

Harlequin. 1888–9. An utterly uncharacteristic subject that briefly interested Cézanne; he painted only four pictures of the sort. The model was his son Paul.

Right: *Man Smoking a Pipe. c.* 1892.
Städtische Kunsthalle, Mannheim.

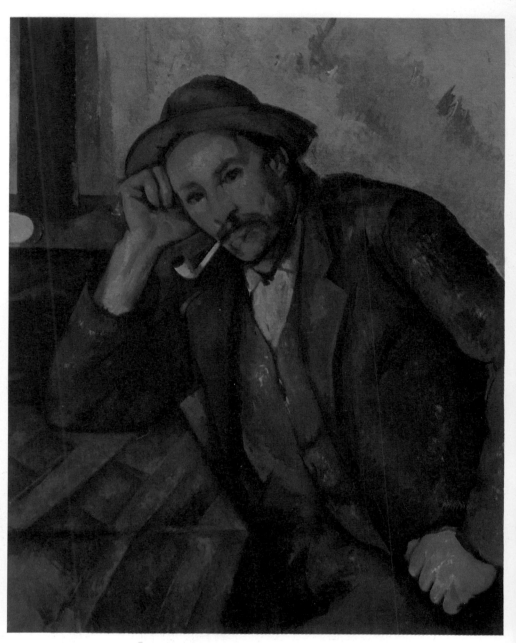

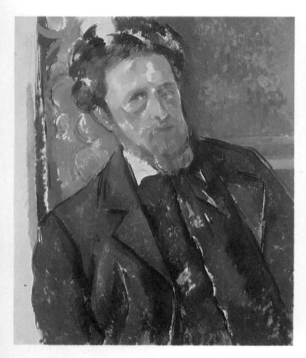

Portrait of Joachim Gasquet. 1896.
Gasquet, a writer, was one of the young
friends Cézanne began to make in his
later years – although, always suspicious
to the point of paranoia, Cézanne came to
feel that Gasquet was merely exploiting
him. National Gallery, Prague.

with Monet and Renoir, made all the more excruciating by his conviction of
artistic superiority and sense of public failure. His frame of mind is clear from a
letter to his son in which he asserted that the younger painters were more
intelligent than his contemporaries who, he wrote with paranoid injustice, 'see
in me only a dangerous rival'.

Despite Cézanne's seclusion, the long, slow groundswell of his fame had
begun. In 1889, thanks to Victor Chocquet, *The House of the Hanged Man* was
shown at the Universal Exposition in Paris. The following year, the avant-garde
Belgian group Les Vingt exhibited some of his work. Then, in 1894, the wealthy
painter Gustave Caillebotte died and left his collection to the state on fairly strict
conditions that, among other things, made it virtually impossible for the
authorities to refuse all Caillebotte's Cézannes; they were therefore hung in the
Musée du Luxembourg and were virtually assured of an eventual place in the
Louvre. More important still, in 1895 Cézanne was at last the subject of a major
exhibition, organized by Ambroise Vollard, an enterprising dealer who was to
figure prominently in the history of modern art. Even those who had known
something of Cézanne's work through frequenting Tanguy's were astonished at
the range and originality revealed by this much wider selection; Pissarro
recorded in a letter to his son the tremendous enthusiasm the exhibition aroused
in him, in Renoir, Degas and Monet. Cézanne had become a 'painter's painter',
if not yet a public success; Maurice Denis's painting *Homage to Cézanne* (1900)
confirmed this by adding a tribute from the younger generation to which
Cézanne ascribed so much intelligence. Other exhibitions followed; the Berlin
National Gallery purchased one of Cézanne's landscapes; and as friends such as
Chocquet and Zola died, the prices fetched at auction by their Cézannes indicated

that the painter was even beginning to achieve commercial reputability.

It was all, perhaps, decades too late for Cézanne, especially since he was denied the one reward he did crave – the 'little bit of ribbon', the Légion d'Honneur, that had so impressed him on meeting Rodin. Such an ambition was appropriate to the role in which he had cast himself, that of a devout, respectable and conservative (if eccentric) provincial gentleman. When the notorious Dreyfus Affair – caused by the wrongful conviction of a Jewish officer for treason – divided France into hostile camps, Cézanne inevitably sided with the militarists, monarchists and clericals against Dreyfus and his supporters; whereas Zola sealed his fame by condemning injustice in his famous newspaper broadside, *J'accuse*. Ironically, when Zola's collection of Cézannes was sold after his death, a monarchist critic instanced the paintings as proof of Zola's degeneracy and viciously denounced Cézanne as a political as well as an artistic subversive! Cézanne had enough ill-wishers at Aix and elsewhere to be inundated with copies of the newspaper containing the article, which was both thrust under his door and sent to him through the post.

Old Woman with a Rosary. c. 1898. In Cézanne's portraits of the late 1890s, his employment of line and volume again became emphatic, giving his figures a monumental presence. National Gallery, London.

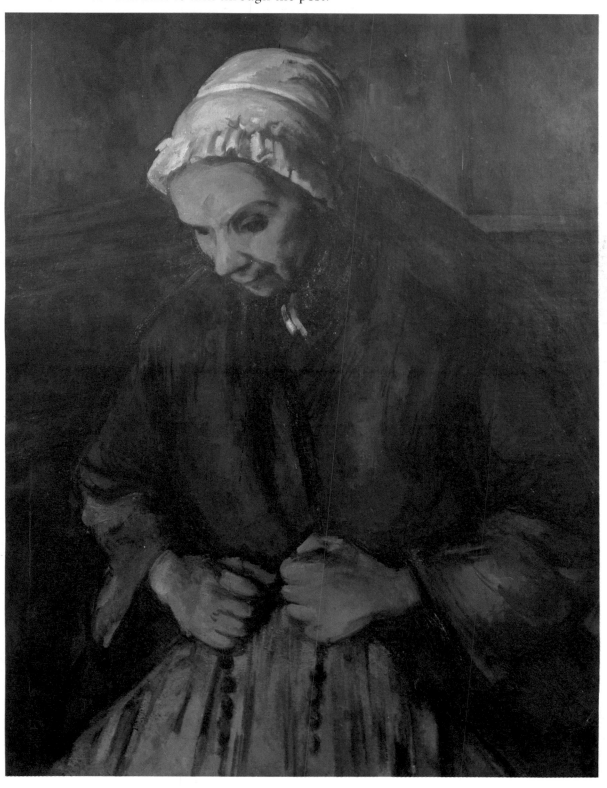

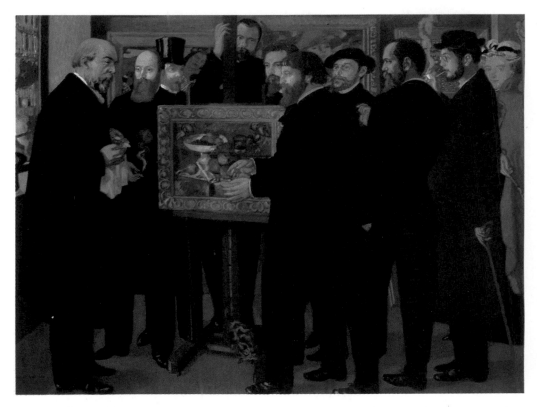

Above: Maurice Denis. *Homage to Cézanne*. 1900. Denis was one of the Nabis, an avant-garde group working in a simplified decorative style. This painting indicates the extent to which Cézanne's influence had begun to be felt among the younger generation. The group shown here, admiring a Cézanne still life, includes the painters Pierre Bonnard, Edouard Vuillard, Odilon Redon and Denis himself, and the art dealer Ambroise Vollard, whose shop is the scene of the painting. Musée du Louvre, Paris.

Left: *Portrait of Gustave Geffroy. c.* 1895. A superb portrait of a Parisian critic sympathetic to Cézanne's work. It is highly structured but also characterful in a manner comparatively rare in Cézanne's art. Private collection.

Portrait of Ambroise Vollard. 1899. According to the famous art dealer Vollard, Cézanne worked on this painting for over a hundred sittings – and then gave up, declaring he was incapable of finishing it. Musée du Petit Palais, Paris.

In his later years, Cézanne found support in the admiration of young artists who made pilgrimages to see him at Aix, and also in the company of more ordinary young men whom chance or conscription brought to the town. The first of these was Joachim Gasquet, a writer whom Cézanne met in 1896 and corresponded with for some years; his portrait of Gasquet (*c.* 1896) is in the Prague National Gallery. However, the majority of these friendships date from the years after 1900. When untroubled by feelings of rivalry, Cézanne could be a pleasant companion, though always liable to go into a state of shock when praised, and susceptible to fits of suspicion; for example, his relations with Gasquet cooled and perhaps eventually ended because Cézanne believed Gasquet was exploiting their friendship in order to build up a valuable collection.

From our point of view, the last of Cézanne's friendships was a particularly fortunate one. In 1904, two years before his death, he received a visit from Emile Bernard, a painter in his mid-thirties. As a very young man Bernard had been a close friend of Van Gogh's and had influenced Gauguin. (Cézanne disliked both men's work; he is said, on very dubious authority, to have met Van Gogh once in 1886 and to have remarked, 'In all sincerity, you paint like a madman!') Bernard had praised Cézanne's work in an article more than a decade earlier, but they had not met, since Bernard then spent many years abroad. In 1904 he and his family stayed with Cézanne for a month, and the two men corresponded until Cézanne's death. Bernard was passionately interested in the theory and philosophy of art – he is in fact more important as a theoretician than as a practitioner – and his questions provoked Cézanne (grumbling all the while) to make some extremely interesting pronouncements. The most famous, although not the most significant for his own art, was his advice to Bernard that he should 'treat nature by means of the cylinder, the sphere, the cone', which no

Right: *Mont Sainte Victoire*. 1902–6.
Watercolour. National Gallery of Ireland,
Dublin.

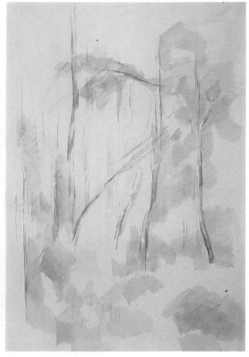

Above: *Sous-Bois. c*. 1887–9. Watercolour
and pencil study. An early example of
Cézanne's use of watercolours, which he
employed with exceptional economy and
freedom. Victoria and Albert Museum,
London.

longer corresponded to Cézanne's practice but was to inspire the Cubism of Picasso and Braque. The letters to Bernard are, however, much more insistent on the need to study the past ('The Louvre is the book in which we learn to read.') and, above all, nature: 'In order to make progress, there is only nature.'

Described in general terms, Cézanne's art can sound limited by the rigour of his approach; in reality, it is extremely varied. The portrait and figure works of the 1890s, for example, range from the colourful, decorative *Boy in a Red Waistcoat* and *Portrait of Gustave Geffroy* (1895), to the more austere *Old Woman with a Rosary* (*c*. 1898) and *Portrait of Ambroise Vollard* (1899), executed towards the end of the decade, in which a renewed emphasis on line and volume gives the figures a tremendous monumental presence. The Geffroy and Vollard portraits are notionally unfinished, since Cézanne was still nervous with strangers and still a perfectionist: Geffroy posed for three months, while Vollard (by his own, perhaps exaggerated account) endured over 100 sittings; and in each instance Cézanne finally abandoned the task, apologizing and declaring that it was beyond him. Vollard told a story about his portrait that is both entertaining and singularly illuminating as to the interrelationships in a Cézanne painting. He asked Cézanne why he had left little bare patches on the hands of the portrait figure, and Cézanne explained that to colour them prematurely might involve re-doing everything else in the picture. Understandably, Vollard said no more.

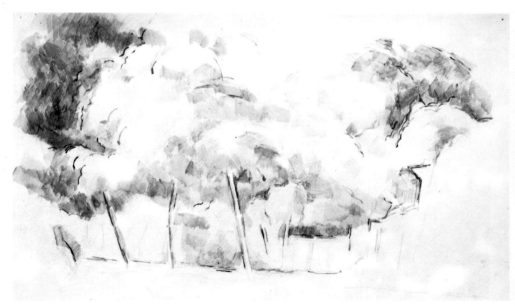

Right: *Trees and Houses. c*. 1890.
Watercolour and pencil study. Museum
Boymans-van Beuningen, Rotterdam.

74

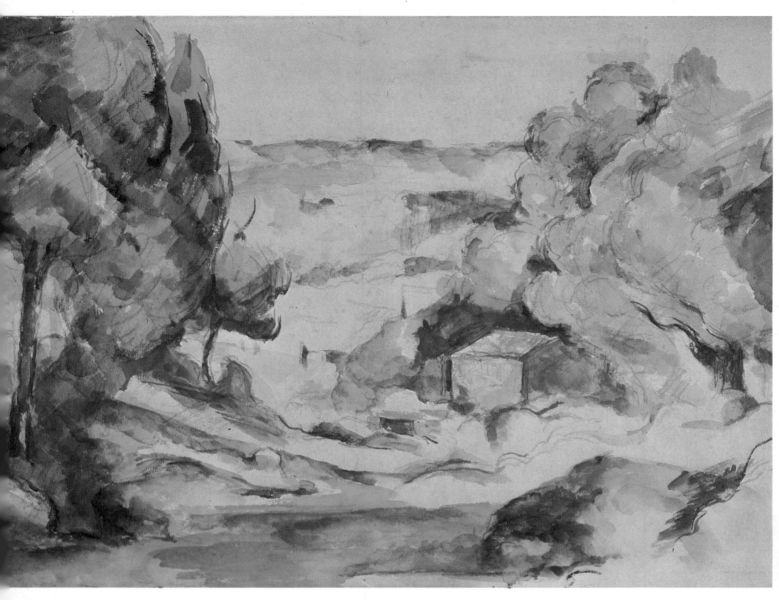

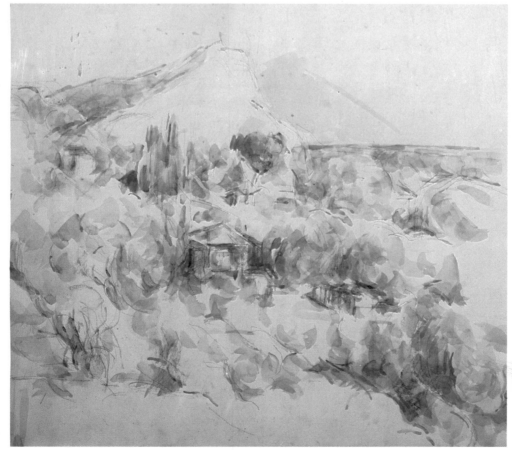

Above: *Landscape in Provence*. 1875–8. Kunsthaus, Zurich.

Left: *Mont Sainte Victoire*. 1900–6. Private collection, Paris.

75

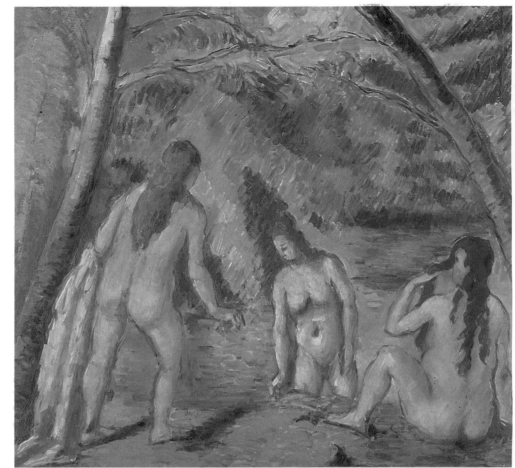

Right: *Three Bathers. c.* 1879–82. By no means the most ambitious but in the opinion of some authorities the most successful of Cézanne's paintings of bathers. The 20th-century master Henri Matisse owned it for thirty-seven years before presenting it to the Museum of the City of Paris. It is now in the Musée du Petit Palais, Paris.

Below: *Bathers.* 1890–4. Executed in a more attractively agitated style than other paintings on this subject. Musée du Louvre, Paris.

Portraits aside, Cézanne's painting in his last years became increasingly colourful and astonishingly free. Watercolour became a favoured medium, no doubt because it handled so easily and allowed for such rapid execution, and even when Cézanne worked in oils he often thinned down the paint so that he could achieve very similar effects. The paint itself was now generally laid on in roughly rectangular patches, as in the late series of Mont Sainte-Victoire studies, and the organization of the picture surface through brush-marks was as important as ever, if less insistent than in Cézanne's canvases of the 1880s. In the delightful 'woodland' (*sous-bois*) paintings and some of the seated-figure studies of Cézanne's gardener, Vallier, there is an airy, light-dappled atmosphere not found in any earlier works. Cézanne's capacity to go on developing to the end of his life makes sense – paradoxically – of the self-discontent he so often expressed: with limitless possibilities still before him, he often became depressed because he had been born too soon and was therefore too old to realize 'the dream of art'.

One of his most persistent efforts was to master the nude figure and integrate it into the landscape. As we have seen, Cézanne's nudes originated with the formless, fleshy, orgiastic figures of the 1860s, and were gradually tamed, becoming amorous wrestlers and finally bathers. In this last form Cézanne returned to the subject again and again. He was inhibited by prudery, and was forced to draw on unsatisfactory sources such as Old Master paintings and some sketches he once made of soldiers bathing, which did duty for later studies of both sexes; the *Great Bather* of the Metropolitan Museum of Art, New York (1885–87), was taken directly from a photograph. The sources were not, of

Bathers. 1898–1905. Private collection, Zurich.

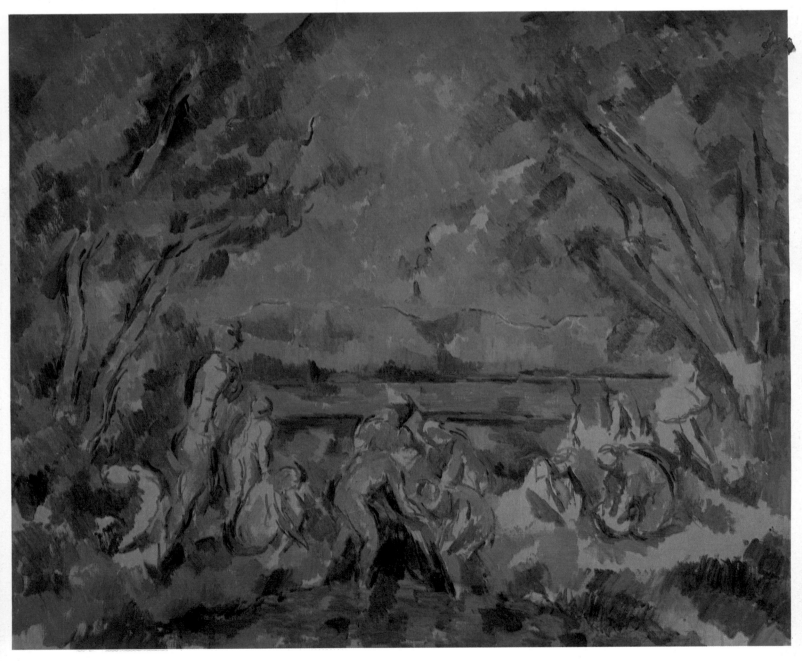

Right: *Portrait of Vallier*. 1902–6. Vallier, Cézanne's gardener, was the subject of several works executed right at the end of the painter's life. Mr and Mrs Leigh B. Block, Chicago.

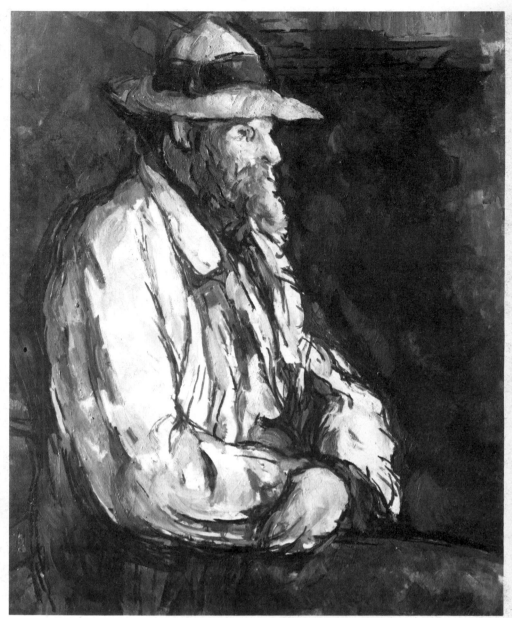

Above: *Portrait of Vallier. c.* 1906. Watercolour and pencil. Private collection.

Far right: *The Gardener. c.* 1906. In his last years Cézanne worked a great deal in watercolours or, as here, thinned down his oil painting pigments to achieve a similar effect. Tate Gallery, London.

course, unsatisfactory in some absolute sense, but an artist who was so insistent on the virtues of contact with nature must surely have found them so; only once, however, did he dare to work from a live model. All Cézanne's efforts in this genre culminated in two paintings (both *c.* 1898–1906), the *Grandes Baigneuses* in the National Gallery, London, and the even larger and more ambitious version in the Philadelphia Museum of Art, in which the assembled bathers are integrated into the pyramidal architectonic design of the landscape. These works have probably divided Cézanne's admirers more than any others. To some, the distortion and crudity of the female forms are insuperable barriers to appreciation, whereas others argue that this objection stems from misplaced expectations, and that Cézanne has here achieved an integration of man and landscape new in European art. To those who hold this latter view – and their numbers include famous modern artists who have been directly influenced by Cézanne – the *Great Bathers* represent the highest point in his career.

Although he was more easily fatigued and had begun to suffer from diabetes, Cézanne's way of life changed little with the years. Instead of his back, a donkey carried his equipment, and later still he used a carriage instead of walking; but, having vowed that he would die painting, he continued to work regularly out of doors. In October 1906 he was still writing with some vigour to his son; but then, having given up his carriage in the belief that he was being overcharged, he was caught in a downpour for several hours, fell ill, and was brought home in a laundry cart. The following day, overestimating his strength, he obstinately worked on a portrait of Vallier in the garden. He took to his bed, dying, while a letter and telegram were sent to alert Hortense and Paul; Cézanne is said to have constantly watched the door in the hope of seeing his son before the end, but Paul arrived too late. Cézanne died on the 22nd of October 1906.

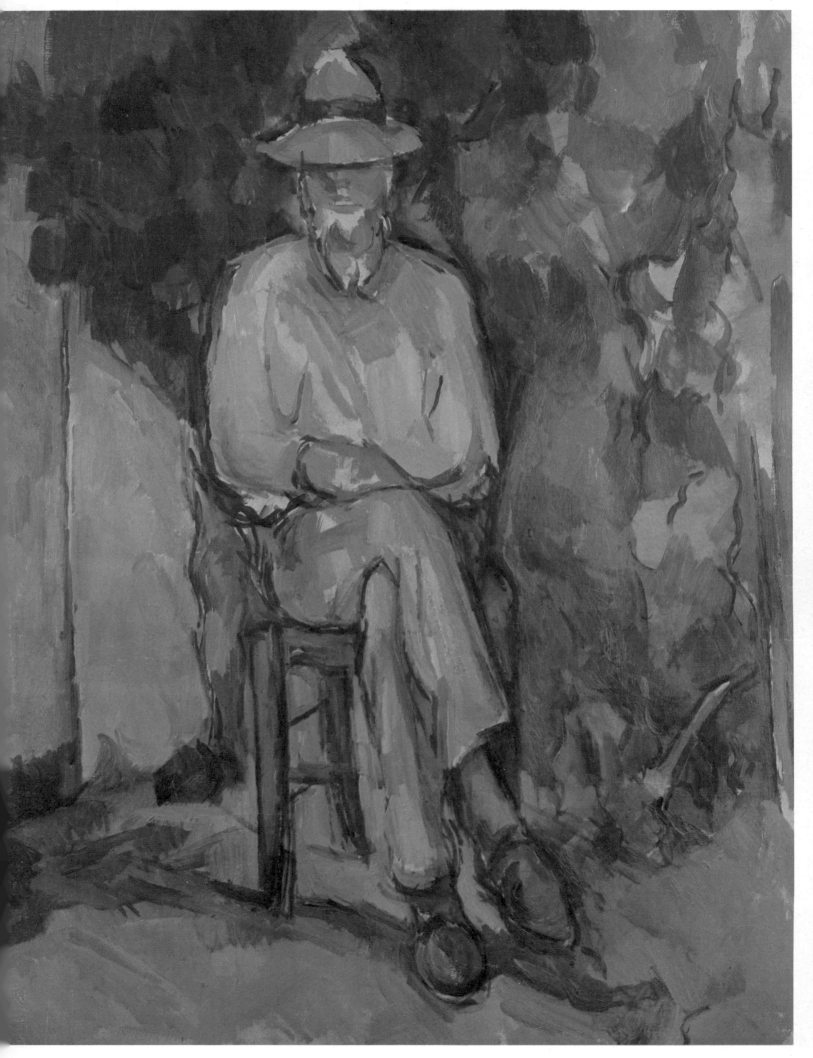

Acknowledgments

Art Institute of Chicago 8 bottom left, 22 right, 33, 34 left, 43, 52 top, 61 right; Art Museum of the Ateneum, Helsinki 51; Arts Council of Great Britain, London 78; Boymans-van Beuningen Museum, Rotterdam 74 bottom; British Museum, London 56 top left; Etablissements J. E. Bulloz, Paris 16 left, 16 right, 17 left, 17 right; Courtauld Institute Galleries, London 13, 66, 68; Fitzwilliam Museum, Cambridge 19, 25 right; Photographie Giraudon, Paris front cover, 6, 9, 10, 29, 31, 32, 40, 49, 55, 61 left, 62, 63, 65, 69 top, 70 right, 71 bottom, 73, 75 top, 75 bottom, 76 top, 76 bottom, 77, back cover; Lauros-Giraudon 27 left, 39, 44, 45, 53; Hamlyn Group Picture Library 11, 13, 18 left, 21, 23, 28 bottom, 42, 47, 50, 56 top right, 58 bottom, 59, 67 bottom, 69 right, 74 left, 78 right, 79; Hamlyn Group: Alberto Flammer 67 top, John Webb 7, 71; Kunsthalle, Basel 46; Kunsthaus, Zurich 35; Kupferstichkabinett, Basel 8 top left, 22 top left, 52 bottom, 56 bottom; Musée Granet, Aix-en-Provence 18 right; Musée Rodin, Paris 38; Musées Nationaux, Paris endpapers, 8 right, 20, 28 top, 30 left, 30 right, 36 bottom left, 40–41, 48, 57, 58 top, 72 bottom; National Gallery, London 54 bottom; National Gallery, Prague 12, 70 left; National Gallery of Art, Washington, D.C. 27 right, 64; National Gallery of Ireland, Dublin 74 top; National Museum of Wales, Cardiff 25 left; Phillips Collection, Washington, D.C. 54 top; Oskar Reinhart Collection, Winterthur 36 right; St Louis Art Museum, St Louis, Missouri 14; © S.P.A.D.E.M., Paris, 1981 72 top; Von der Heydt Museum, Wuppertal title spread, 34 right; Walker Art Gallery, Liverpool 24; Wildenstein & Co Inc, New York 26; Ziolo, Paris 15, 37.

Front cover: *The Blue Vase. c.* 1885–95. Musée du Louvre, Paris.
Back cover: *Man Smoking a Pipe. c.* 1892. Courtauld Institute Galleries, London.
Endpapers: *Still Life with Apples and Oranges. c.* 1895–1900. Musée du Louvre, Paris.
Title spread: Detail. *The Hermitage, Pontoise.* 1875. Von der Heydt Museum der Stadt, Wuppertal.